IMAGES
of America
FREEDOMLAND

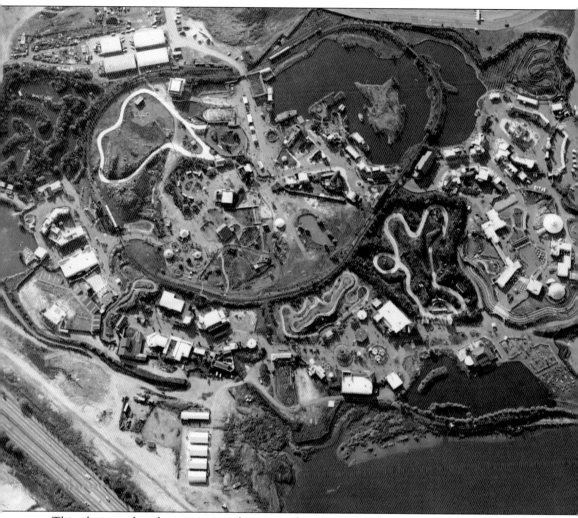

This photograph, taken sometime during or after the 1962 season, shows the entire layout of Freedomland minus the huge parking lot. (Courtesy of Frank R. Adamo collection.)

ON THE COVER: In a guide for employees, Freedomland's publicity director Ed Weiner describes the Great Lakes Cruise: "Two authentic sternwheelers, built by the Todd Shipyards in Hoboken, New Jersey, will take our guests on a cruise through the Great Lakes. They will pass hunters, wildlife, Indians, tugboats, war canoes, and many fine attractions." (Courtesy of Frank R. Adamo collection.)

IMAGES of America
FREEDOMLAND

Robert McLaughlin and Frank R. Adamo

Copyright © 2010 by Robert McLaughlin and Frank R. Adamo
ISBN 978-0-7385-7264-2

Published by Arcadia Publishing
Charleston, South Carolina

Printed in the United States of America

Library of Congress Control Number: 2009936359

For all general information contact Arcadia Publishing at:
Telephone 843-853-2070
Fax 843-853-0044
E-mail sales@arcadiapublishing.com
For customer service and orders:
Toll-Free 1-888-313-2665

Visit us on the Internet at www.arcadiapublishing.com

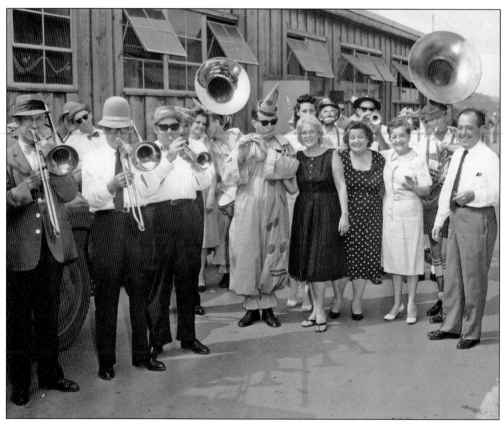

Freedomland is dedicated to the thousands of cast members, employees, designers, and the construction workers who built the park. All the guests thank you for a lifetime of memories.

Contents

Acknowledgments		6
Introduction		7
1.	Concept to Opening Day	9
2.	From 1960 to 1964	31
3.	The Entertainers	97
4.	After Freedomland	119

ACKNOWLEDGMENTS

Coauthor Bob McLaughlin started research on Boston's (Wakefield) Pleasure Island back in 2000. McLaughlin met a lot of interesting people along the way. One was Dr. Todd Pierce from California Polytechnic State University, who contacted him in the fall of 2005. Pierce has written a yet-unpublished book about Disneyland, Magic Mountain (Colorado), Pleasure Island, and Freedomland. That gets us to Frank R. Adamo. McLaughlin was fortunate to accompany Pierce on some of his interviews and Adamo's was one of them. After seeing Adamo's photograph collection, McLaughlin learned that he not only worked on constructing Freedomland but also served as equipment superintendent during construction. He went on to Freedomland management even before the park opened. He was also in charge of dismantling the park and, at the end, running the massive landfill project at the former site. He worked at this location for 17 years. Readers will enjoy his collection of knowledge and photographs.

Bob wishes to thank his wife Terry and granddaughter Danielle. For the second time in one year, they got to translate a dyslexic writer's text into its final form. Bob would also like to thank his children, Kerry, Jamie, Tracy, and Micah, for putting up with their dad's hobby (theme parks) for the last 10 years. Bob and Frank are grateful to Erin Vosgien and Tiffany Frary from Arcadia Publishing for all the help along the way. To Frank's daughter, Elizabeth Raucci, for receiving and discussing copy, thank you. Dana Parra, permissions coordinator for *Billboard* magazine, could not have been more helpful. Thank you to Lauri Tosi, librarian for the Bronx County Historical Society. It was a well-spent morning at your library for this project. To Richard W. Symmes, a local train historian who helped on some of *Freedomland*'s train captions, thank you. Rebecca Close, communications director for Six Flags Great Escape and Splash Water Kingdom, and David A. Clark from Clark's Trading Post were a great help with the fourth chapter. Bob would like to thank the many entertainers that he was able to locate and speak with. You have all made this project worthwhile. Thanks again to Frank for saving a piece of history through his photograph collection and excellent memory.

Unless otherwise noted, all images appear courtesy of the Frank R. Adamo collection.

INTRODUCTION

Through images and information gathered from a variety of sources, the history of Freedomland, through four chapters, will tell the story of the "Disneyland of the East." To understand how Freedomland came to be, it is important to explore the evolution of amusement parks in America.

Amusement parks have been around for a long time but got a big boost when trolley cars started crisscrossing the American urban landscape. The trolley companies built trolley parks at the end of their lines to shore up their bottom line. Because the companies paid for electricity seven days a week, they lost money when the trolleys were not carrying paying customers. Trolley parks gave people a reason to ride the trolley on the weekends. Many of America's first amusement parks started out as trolley parks. Some are still operating today. With the automobile came roadside Santa's Villages, dinosaur parks, Mother Goose zoos, reptile farms, frontier towns, and many others. Clark's Trading Post in Lincoln, New Hampshire (described in chapter four), started out as a roadside attraction.

On July 17, 1955, a completely new type of amusement park opened. It was called a theme park, and that park was Walt Disney's Disneyland in Anaheim, California. The concept was themed entertainment in a clean, controlled environment and was unlike any amusement park in America and even beyond.

In 1953, Walt and Roy Disney hired Stanford Research Institute to do a study to pick the location for Disneyland. The head of the team for this assignment was young Cornelius Vanderbilt ("C. V.") Wood Jr. from Texas. This study not only chose the location for Disneyland but—relying on travel and population trends, past weather cycles, and many other factors—projected how many guests would come and how much they would spend. The Disney brothers were so impressed with this study that they hired Wood and made him Disneyland's first vice president.

Wood was involved in many aspects of getting Disneyland from the drawing board to completion. The idea of Disneyland was essentially that of a large movie set, and Wood and the Disneys hired many of the most talented people in the movie industry to create Disneyland, including set designers, special effects personnel, and artists. Within two years of the start of the Stanford study, Disneyland opened, and the theme park business was born.

Wood became Disneyland's first general manager, but after just months, he left to start up his own company, Marco Engineering. With postwar income increasing, America's love affair with the automobile continuing, and the U.S. road system upgrading in the 1950s, investors started to take a closer look at the Disneyland model.

Wood then proceeded to hire away several key Disney employees, earning Disney's everlasting ill will. Marco Engineering had just what investors were looking for—the talent, experience, and playbook to design Disneyland-type parks anywhere they were willing to pay for them. Marco Engineering initially got involved in several existing park upgrades, but its first stand-alone theme park was built in Golden, Colorado: Magic Mountain, just west of Denver. Construction there

started in 1957. The partially finished park operated during the summers of 1958, 1959, and 1960. However, lawsuits and other factors contributed to its demise.

The next C. V. Wood Jr. theme park was Pleasure Island, billed as Boston's answer to Disneyland. It opened on June 22, 1959. William Hawkes, president of *Child Life* magazine, and executives at Cabot, Cabot, and Forbes collaborated with Marco Engineering to build an 80-acre theme park in Wakefield, Massachusetts. In 1959, the investors that created Pleasure Island, along with others such as Ted Raynor, Herbert Lee, and Peter De Met, formed International Recreation Corporation (IRC).

As early as 1957, C. V. Wood Jr. had been in discussions with Raynor and others about a concept for Freedomland. Meanwhile, William Zeckendorf Sr., who controlled the Webb and Knapp development company, was sitting with 400 acres of developable land in the Baychester area in the northeastern part of the Bronx, New York. Webb and Knapp struck a deal with IRC: the former would lease 205 acres to the latter. Freedomland was born.

Among the staff hired away from Disney by C. V. Wood Jr. was Van Arsdale France. He had been hired by Disney to set up a training program for its soon-to-open theme park. He also established Disney University. After moving over to Marco in 1959, France's first assignment was to set up the training program for Pleasure Island. France next performed similar duties at Freedomland. Shortly after this, France returned to Disneyland and continued to work for the Walt Disney Company until retirement. The archives from the Friends of Pleasure Island feature two France-produced training manuals for Freedomland, *A Guide For Supervision and Working for Men* and *Tips for Talkers*. The latter manual tells new employees: "Be yourself. Enunciate your words. Avoid 'off color' jokes and remarks. Pick a guest as your listener. Bring your listener into the act. Know your facts and use them."

This last tip segues to another Freedomland manual for employees and cast members. Ed Weiner, Freedomland's first publicity director, wrote *This is Freedomland*, the A to Z description of the soon-to-open park. It described each section of Freedomland, including details on the park's attractions, restaurants, and amenities. *This is Freedomland* proved very useful while researching this book.

Detail was the key to every aspect of Freedomland. As an example, rather than merely filtering in already-existing theme music into the parks different sections, Freedomland Inc. retained American composer Jule Styne (*The Bells are Ringing, Gentlemen Prefer Blondes, Pal Joey,* and *Gypsy*) and lyricist George Weiss to create the music for the Freedomland soundtrack, which was then arranged and performed by an orchestra led by arranger/conductor Frank De Vol. The tunes were played continually in the appropriate section of the park. A number of established artists performed the songs, including Richard Hayes, who sang "Little Old New York" and "San Francisco Fran," and dueted with Jill Cory on "The Jalopy Song;" Earl Wrightson, who sang "Satellite City" and "Chicago Fire;" Charlie Weaver (Cliff Arquette), who performed "Danny the Dragon;" Johnny Horton, who sang "Johnny Freedom;" and blues vocalist Jimmy Rushing, who sang "So Long Ma" for the park's New Orleans-Mardis Gras section. Naturally a soundtrack album was available at Freedomland's souvenir shops.

A preview event was held June 18, 1960, and on opening day, Sunday, June 19, an estimated 63,000 guests arrived at Freedomland. Just over four years later, in September 1964, the park shut its gates for the last time and filed for bankruptcy. Disney had sued C. V. Wood Jr.'s Marco Engineering in May 1960 over misrepresentation, including Marco's unauthorized use of Disney trademarks for promoting their parks. This suit eventually ended Marco Engineering's involvement in the theme park business. Wood joined forces with Robert McCulloch (of outboard motor and chainsaw fame), purchased the London Bridge, dismantled it, and rebuilt it in the Mojave Desert town of Lake Havasu City, Arizona. A small British-themed village surrounds the bridge.

A whole book could be written about the business end of all three of C. V. Wood Jr.'s parks—and fortunately it has. Dr. Todd Pierce's upcoming (and as-yet-untitled) book tells the story from Disneyland to Freedomland. For additional information, check out *Zeckendorf: An Autobiography of William Zeckendorf*, published by Holt, Rinehart, and Winston.

One

Concept to Opening Day

The shortness of the time span between the earliest public announcements about a new theme park to be built in the Bronx (May 1959) and Freedomland's opening day (June 19, 1960) is staggering. From permitting to design to developing the site to construction to opening day took just over one year. The following excerpt is from an article in *Billboard*, May 4, 1959, "The Board of Estimate of the city of New York in considering the proposal of a syndicate to lease property from Webb and Knapp. The proposed site is half of a 400-acre area in the Baychester section of the Bronx." Marco Engineering of Los Angeles was retained early on to conduct an economic appraisal of the proposed undertaking. During March, June, and July 1959, Marco conducted field surveys with which it collected data for estimating attendance, cost, and income. Afterwards, it prepared a preliminary park design.

James E. Thompson and Patricia Kimball conducted these economic studies. Thompson was Marco's director of research. He was an economics consultant to Disneyland during its planning, engineering, and construction phases. Kimball was a senior research economist for Marco; Wade B. Rubottom directed design and layout for Freedomland as Marco's executive art director. Rubottom spent 19 years as art director at MGM and other major motion picture studios. He also designed Main Street U.S.A. at Disneyland. Marco's co-art director was Randall Duell, who had also codesigned Boston's Pleasure Island. Duell was art director on 65 movies such as *A Blackboard Jungle* and *Singin' in the Rain* before being tapped to work for Marco by C. V. Wood Jr.

Randall Duell moved on to start the Duell Corporation, which designed amusement parks around the world. His son, Roger Duell, recalls working on Freedomland for Bill Maker, who created color schemes, props, and dressings throughout the park. The building of Freedomland was a joint venture between Turner Construction Company of New York, New York, and Aberthaw Construction Company of Boston. Ed O'Brien was the general superintendent of construction. Aberthaw had just completed Boston's Pleasure Island in June 1959, just as Freedomland's site work was starting up. Through the following photographs, it is amazing to watch the process of Freedomland's construction up to opening day, June 19, 1960. To get an idea of the costs, from admission to construction throughout this book, multiply the amounts mentioned in the following pages by 7.2 to get the approximate worth in 2009 dollars.

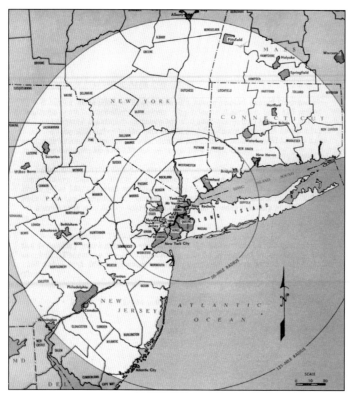

Marco Engineering, designers of Freedomland, delivered a report dated August 1959 to IRC. The 76-page *Economic Appraisal of Freedomland* covered topics such as estimated attendance and the factors affecting the same, themes, design and layout, cost estimates, and income forecasts. In 1960, an estimated 16 million people lived within the park's primary marketing area—everything within a 50-mile radius of the park site, which included all of Long Island. (Courtesy of Friends of Pleasure Island.)

The secondary marketing area (outer circle) had an estimated population of about 9.9 million. The appraisal predicted a total annual attendance of 4.8 million (about 25 percent of the total population within the 50-mile radius). The map at right (from the same report) shows Freedomland's proposed location in the Bronx. (Courtesy of Friends of Pleasure Island.)

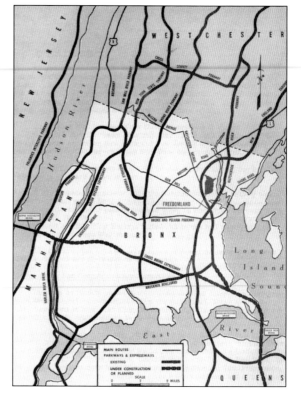

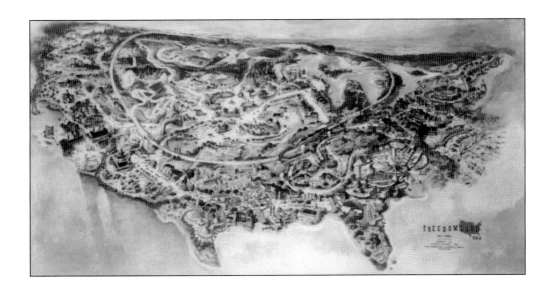

The rendering (above) is a bird's-eye view of Freedomland by Marco Engineering artists. These drawings were conceptual, and, as in all three parks Marco Engineering had designed to date, were exaggerated from what would actually be built. The rendering below is the Chicago Fire attraction. Notice the ship on fire—this never made it to the final design. Many of these renderings, however, were sold as postcards at the park's gift shops. (Below, courtesy of Robert McLaughlin.)

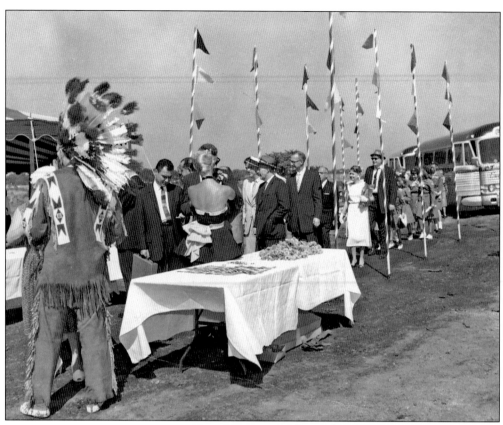

Groundbreaking ceremonies for Freedomland were held starting at 10:00 a.m. on Wednesday, August 26, 1959. Freedomland would open for its first season on June 19, 1960, in less than a year. Part of the lineup for the festivities included a group of Girl Scouts, shown here just coming off of their bus.

Here are Boy Scouts with the Girl Scouts during the flag ceremony. The festivities also included costumed actors representing the different historic eras to be built at Freedomland, as well as the 60-piece Sanitation Department band.

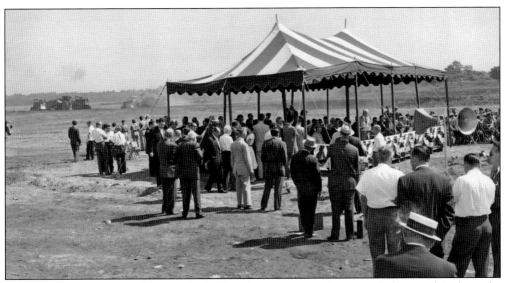

A large catering tent stood beside the VIP and guest speakers' tents. A helicopter hired to take photographers up over the site for aerial shots landed shortly after the start of the groundbreaking ceremony, kicking up a dust storm that spread throughout the ceremony area, including the catering tent. Seen here at the microphone is the acting mayor, Abe Stark.

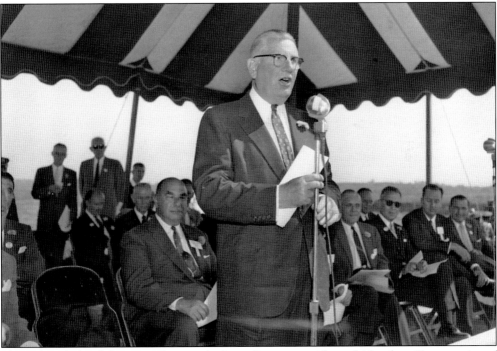

Shown here behind the microphone is Ambrose Burton, president of Aberthaw Construction of Boston. Seated behind him is William Zeckendorf Sr. Second from right is C. V. Wood Jr. Other speakers included borough president James Lyons and quiz show winner, Columbia University professor, and *Today* show cultural correspondent Charles Van Doren, who served as emcee. Within three months, Van Doren would admit his involvement in the 1950s quiz show scandals to a U.S. Congressional subcommittee, lose his *Today* job, and resign his faculty position.

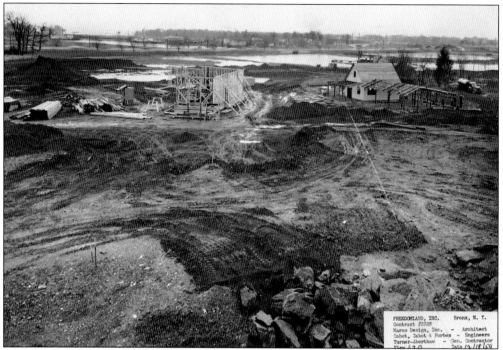

By November 1959, reportedly more than a million square feet of earth had been shaped to resemble the contour of America. Many of the foundations had been poured or were being poured ahead of the upcoming winter. To the right is the entrance building for the Northwest Trappers ride, under construction. On the left, San Francisco's buildings are just getting started. In the background is Rudy's Barge, which was a local bar and restaurant.

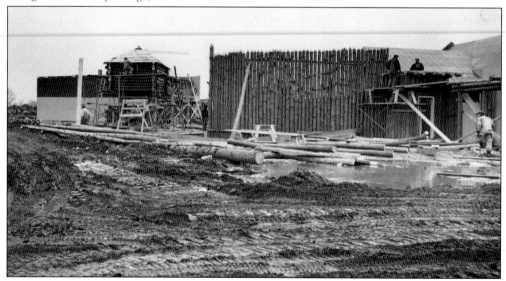

This January 4, 1960, photograph shows that Fort Cavalry is well under way. Note the fort structure to the left: two similar buildings were constructed as part of C. V. Wood Jr.'s Magic Mountain theme park in Golden, Colorado. Though that park has been renamed Heritage Square, many of the original buildings still exist. They are the last Marco-designed buildings still in use at their original location.

This photograph was taken on January 12, 1960. Coauthor Frank R. Adamo is operating the Caterpillar 977 front-end loader, while the pile driver is full steam ahead. The first structures constructed at Freedomland were the maintenance buildings. These were used to build components for the rest of the park, such as the prefabricated top of one of the park's buildings, shown on the left in the photograph.

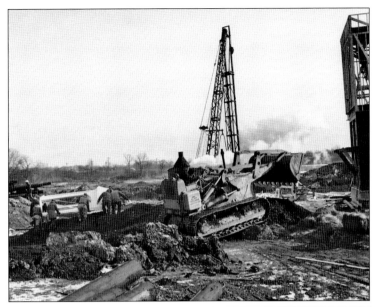

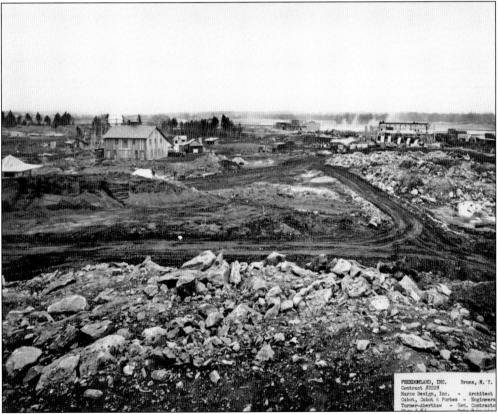

The Borden Company sponsored the farm area shown in this photograph. On the far left is the Milk Bar stand. On February 8, 1960, *Billboard* reported that "there are 42 buildings in various stages of construction. The Great Lakes are basically complete, the Northwest Passage waterways and terraces are sculpted, and half of the Rocky Mountains are shaped."

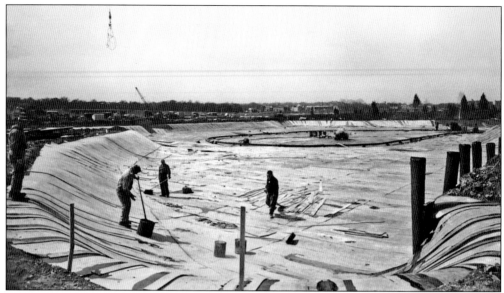

This photograph of the Great Lakes under construction should clear up any rumors that the lake bed was lined in concrete. Also shown is the guide rail for the stern-wheelers in the lake bed. According to Adamo, turbulence from the stern-wheelers' paddles caused maintenance problems with the lake bed for the life of the park. (Courtesy of Frank R. Adamo collection; photograph by Guy Gillette.)

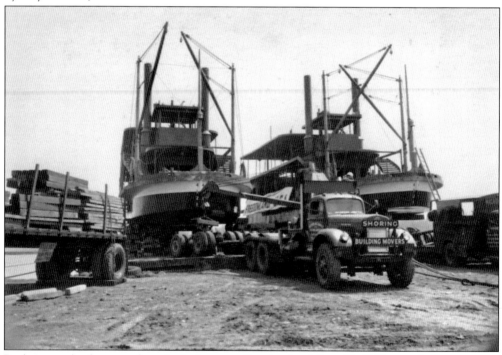

Both stern-wheelers were brought by barge to Freedomland from Todd Shipyards Corporation, Hoboken Division, where they were built. From the Hutchinson River abutting the park, they were transported by Nicholas Brothers Building Movers to the Great Lakes site and into the lake bed.

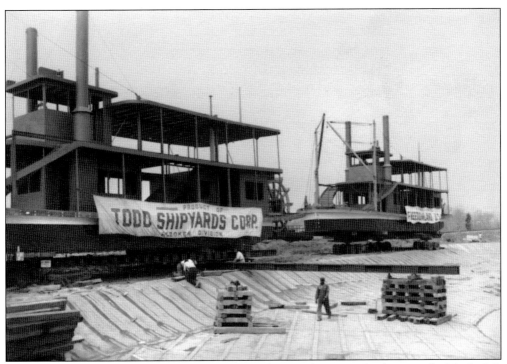

These photographs show the amount of effort it took to get the stern-wheelers into the lake bed. It also cost a large amount of money: the total budget for the design, manufacturing, transportation, and installation of both stern-wheelers was $384,000 in 1959 dollars.

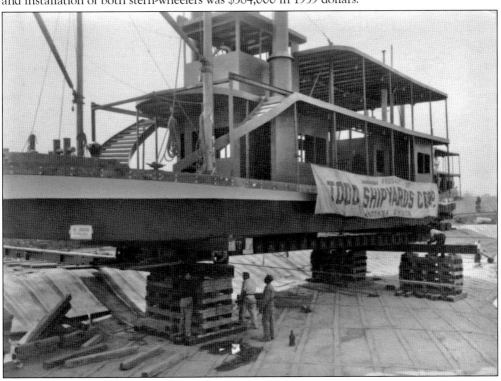

Freedomland hired Winfield H. Hubbard's Denver firm, Special Effects, to set up the animation for the Northwest Fur Trapper attraction. He was the special-effects chief for C. V. Wood Jr.'s first theme park, Magic Mountain in Golden, Colorado. Freedomland purchased the ride's animation from Magic Mountain for $95,000. Hubbard, like much of the talent working for or with C. V. Wood Jr., came from the movie industry.

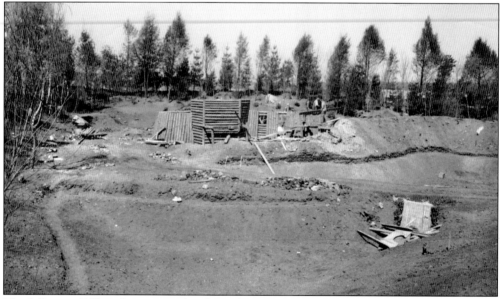

The following *Billboard* excerpt is dated April 11, 1960: "At one time or another close to 2,500 men have been working at the Freedomland site. About 200 of the total of 248 buildings are under construction." This photograph shows part of the Civil War attraction being built.

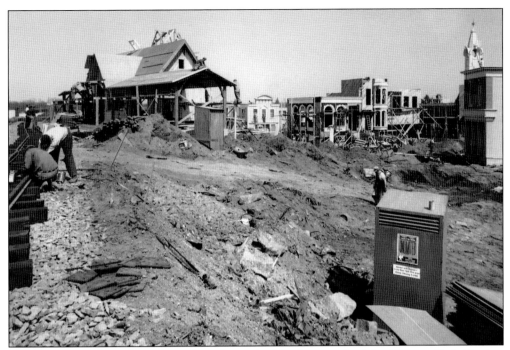

Work continues throughout the park, as shown in this photograph of the Chicago Train Station for the Santa Fe Railroad with Little Old New York under construction. To the left, the tracks for the Santa Fe Railroad are being laid.

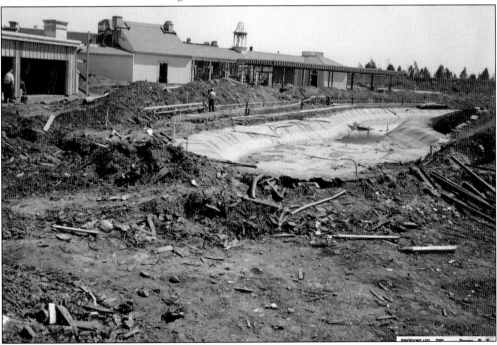

This is part of the Horseless Carriage ride. Notice the membrane system, a "carey mat," used for the scenic pond. It was the same system used for the Great Lakes. The Northwest Fur Trapper attraction was lined in concrete. To the left is the maintenance shop for the antique cars.

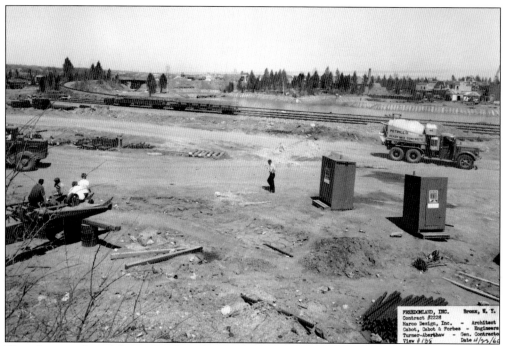

This photograph and the one on the opposite page give an interesting view of Freedomland under construction. On the left is one of the two trestle bridges that spanned the Great Lakes.

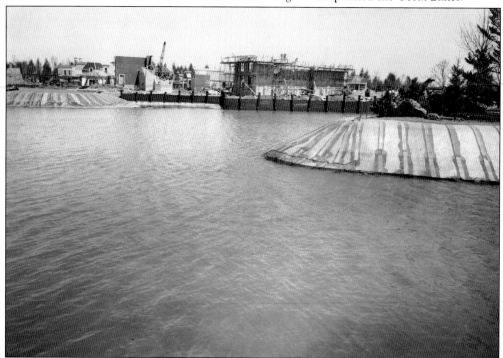

Across a partially filled Great Lake, the Chicago Fire attraction is under construction. This photograph was taken on Friday, April 22, 1960. Workers had less than two months left to complete Freedomland for opening day, already announced as June 19.

This photograph shows a crew working on the Santa Fe Railroad tracks, while other workmen are at the builder lunch car on the right.

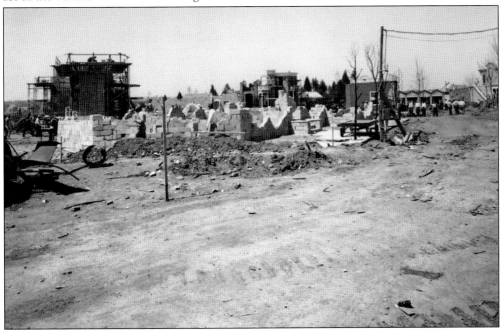

Workers are shown here building the Chicago Fire attraction. On March 23, 1960, a real fire broke out at Freedomland. *Billboard*, from March 28, 1960, noted that the 200-foot building for the Pirates ride had burned to the ground in "a blaze visible for miles." The fire destroyed four other buildings as well. Pieces of fire debris were used as props for the Chicago Fire attraction.

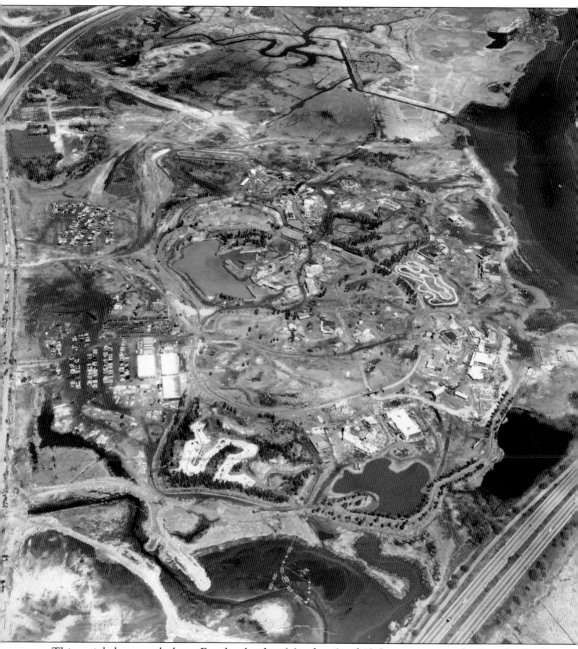

This aerial photograph shows Freedomland on Monday, April 18. In just two months, Freedomland would host its opening. The May 2, 1960, edition of *Billboard* noted "that after drawing interest with huge newspaper display ads, the mammoth amusement spread in the Bronx had played host to a busload of journalists." With the New England Thruway on the left and the Hutchinson River Parkway on the right, Freedomland is looking huge. (Courtesy of Frank R. Adamo collection; photograph by Thomas Airviews.)

This photograph shows the gingerbread trim being installed on one of the stern-wheelers in the Great Lakes. According to *This is Freedomland*, Gene Angel designed the boats, while Earl Hart designed the boats' elaborate decorations. The guide proudly informs employees (so that they can, in turn, tell park guests) that these same two men had designed and built the stern-wheeler used in the MGM musical, *Showboat*.

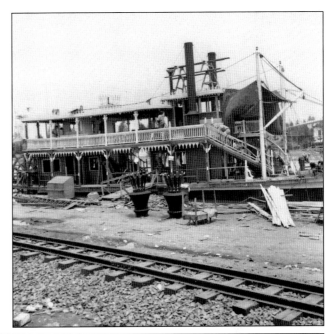

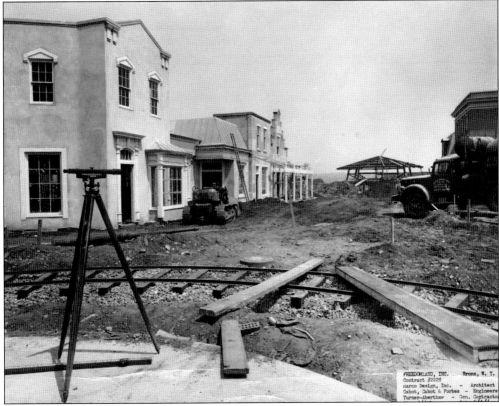

Looking down from Little Old New York is Satellite City, with just the steel frame of the Space Ship in view. In Little Old New York, the tracks are in place for the horse-drawn streetcars. This photograph was taken on Friday May 6, 1960, just 44 days before opening day.

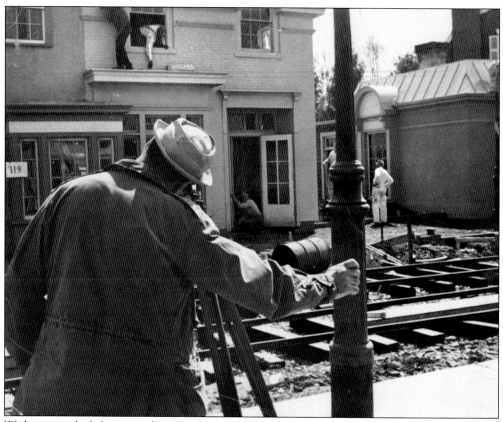

With just weeks left to complete Freedomland, workmen are busy on some of the shops in Little Old New York. Tracks for the horse-drawn streetcars are being installed, and grades are being checked for the next step, the concrete sidewalks.

Every building at Freedomland not only had a name but also had an address number, which has been helpful while researching the park using an original site master plan. Progress continues leading up to opening day.

While famed talking chimp Kokomo Jr. poses for a publicity shot, construction continues on the Braniff International Airways Space Rover (later named the Space Ship).

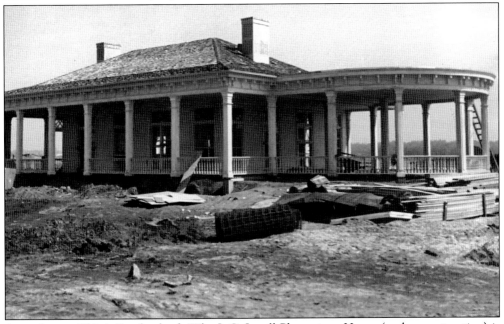

According to *This is Freedomland*, "The J. C. Jewell Plantations House (under construction) is named after the world's largest chicken producer in Kingsville, Georgia. This restaurant will feature Southern fried chicken at its best. The restaurant is right on the Gulf of Mexico."

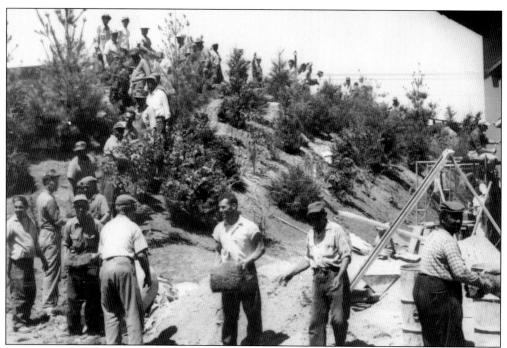

This photograph speaks volumes about the amount of manpower at the park, especially towards opening day. Here a work crew hands sod up to installers, while carpenters work to finish up the building on the right.

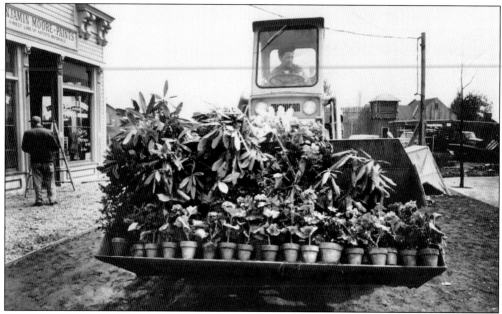

Lawrence Labriola Nurseries reportedly planted 50,000 trees and shrubs throughout Freedomland. Here a Naclerio Contracting front-end loader transports some of those plantings. According to *This is Freedomland*, there are 8 miles of navigable rivers, lakes, and streams; 500,000 yards of paving; 75 tons of plaster; 1,233,000 cubic yards of land moved; 150 miles of electrical wire; 4,000-5,000 signs prepared, and 19 Oscar winners among the hundreds of designers of Freedomland.

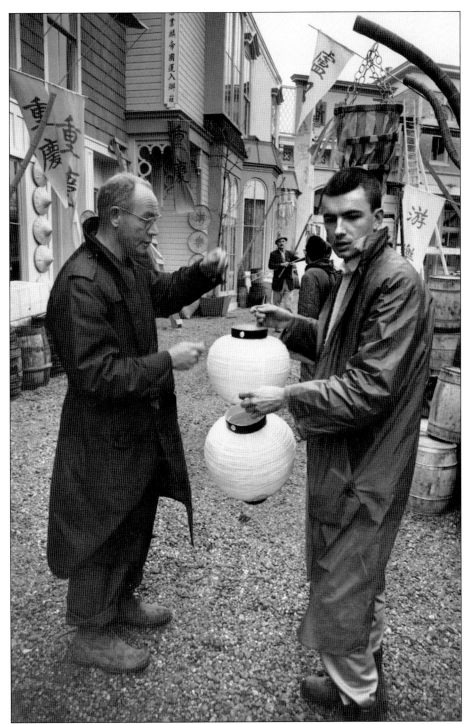

Freedomland set a standard for detail that most parks have not come close to matching, before or since. The quality of design and construction throughout the entire park, including backstage, is illustrated in this photograph of San Francisco's Chinatown getting its finishing touches for show time—Freedomland's opening. (Frank R. Adamo collection; photograph by Guy Gillette.)

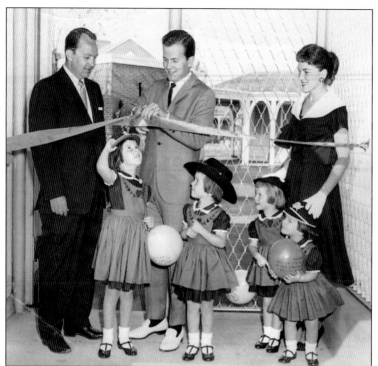

On June 19, 1960, Freedomland opened to an estimated 63,000 visitors. C. V. Wood Jr., whose company, Marco Engineering, designed Freedomland, looks on as Pat Boone cuts the opening day ribbon. Also pictured from left to right are Boone's four daughters, Cherry, Lindy, Debby, and Laury, and his wife, Shirley Foley, daughter of country music great Red Foley.

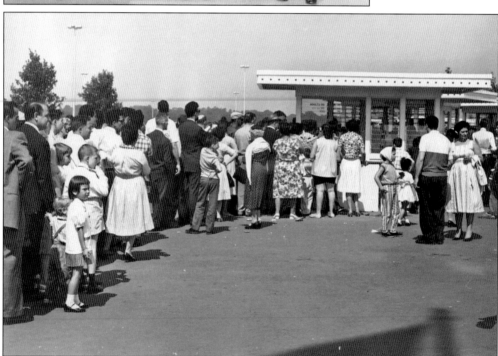

These guests, decked out in their Sunday best, are about to take a step into America's history—and its future. But first comes the admission booth. For adults, admission was $1 including tax; for 13–17 year olds, 75¢; and for smaller kids, 50¢. The park had 27 rides and attractions, each of which required tickets priced from 10¢ to 50¢. Parking was 50¢.

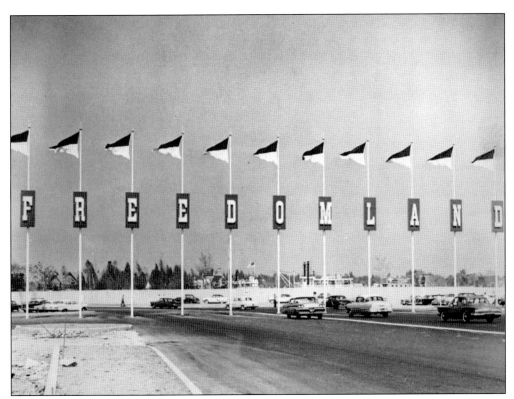

What a thrill it was for children and their parents to enter in to the "Disneyland of the East." Along with all the scenery on opening day came the distinct odor of newly poured asphalt; crews had paved Freedomland's parking lot just days earlier.

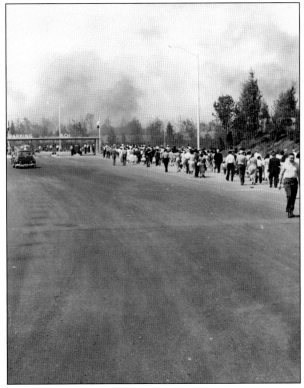

According to several sources, on opening day, June 19, 1960, radio announcers asked people *not* to head to Freedomland's overflowing parking lot. Thousands of cars spilled into surrounding neighborhoods to park with some people walking more than a mile to Freedomland. In this photograph, the smoke from the Santa Fe Railroad locomotives is visible.

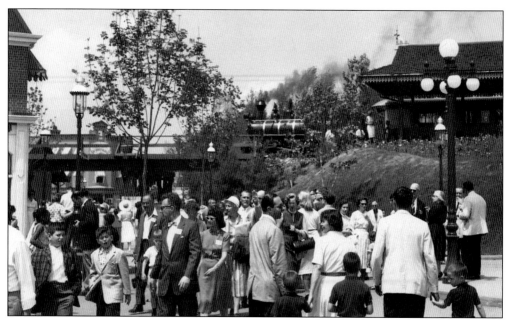

These guests are in Chicago on Dearborn Street. A walk under the Santa Fe Railroad trestle bridge will land visitors in Little Old New York. To the right stands the Chicago Station.

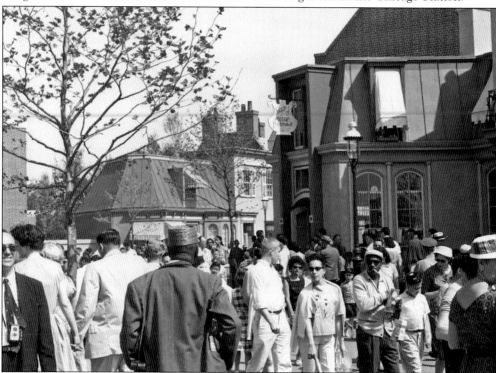

It is hard to believe that a site consisting of lowlands, farms, and a landfill just a half an hour from Times Square (as the park advertisements suggest) could be converted into the Disneyland of the East so fast. Filling and leveling started around June 1959. Ten months after the official groundbreaking in August, Freedomland was open.

Two
FROM 1960 TO 1964

With opening day behind it, Freedomland set sail on its own roller-coaster ride for five seasons. According to Frank R. Adamo and other sources, cost overruns for construction ballooned the original budget of $17.5 million to over $21 million. Just like Disneyland and Pleasure Island, parts of the park were just not completed in time for opening day.

On July 11, 1960, *Billboard* announced that Freedomland's Satellite City section had opened to the public on the weekend of July 2 and 3, rendering the theme park fully operational. Though "virtually complete at the June 19 official opening," the magazine explained, Satellite City had been "delayed by electrical work difficulties."

The price of park admission varied throughout Freedomland's five-season run. The first season started with general admission plus separate tickets per ride. By August 8, 1960, *Billboard* frankly reported that admission had been increased because "gate revenue from the original prices weren't meeting the overhead." By Freedomland's second season, a pay-one-price policy went into effect; the price of admission included all attractions and shows. Admission in 1961 was $2.95; by 1962 it was $3.50. By 1963 and 1964, admission price had been reduced to $1. Local advertising showed thrilling new rides, exhibits, and attractions starting at just 10¢.

There was no lack of advertising for Freedomland, especially in the early seasons. National attention came early, on Freedomland's opening day, Sunday, June 19, 1960, with a segment on the *Ed Sullivan Show*. Sullivan had taped a tour of the park the day before at Freedomland's premiere. Later that summer, the August 1, 1960, issue of the prestigious *Life* magazine featured eight Freedomland photographs in a story on the growth of themed amusement centers. Local television and radio spots featured the tag line, "Mommy and Daddy, take my hand. Take me out to Freedomland."

The sad news is that all this lasted for just five seasons. The good news is that, in the early 1960s, hundreds of thousands of park guests, young and old, got their own Disneyland-type park, and thousands of local teenagers enjoyed memorable summer employment. This chapter takes readers back to Freedomland, one attraction at a time.

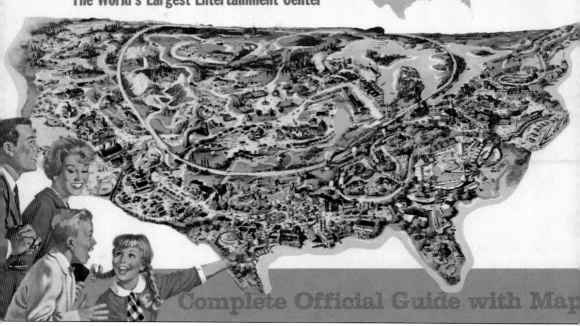

This is the front cover of the official guide for Freedomland's opening season in 1960. With a total of 18 pages, the guide describes each of the park's seven sections. A two-page map features color-coded markings for restrooms and restaurants. Original color renderings of the described attractions were used because the guide was printed before the park's opening day, and thus, before the park was complete.

FREEDOM LAND

The World's Largest Outdoor Family Entertainment Center

featuring these exciting attractions

LITTLE OLD NEW YORK: 1850-1900

HORSELESS CARRIAGE	HARBOR TUG BOATS	HORSE-DRAWN STREETCAR	HORSE-DRAWN SURREY	POLITICAL PEP RALLY
Drive a 1909 model Cadillac through scenic New England.	Sail through the Great Lakes on a real steam tug boat.	Travel New York to Chicago on an old-fashioned horsecar.	The "surrey with the fringe on top" takes you to Chicago.	A Tammany speech of the 1880's, a German Band, suffragettes.

CHICAGO: 1871

THE CHICAGO FIRE	GREAT LAKES CRUISE	CHIPPEWA WAR CANOES	INDIAN VILLAGE	SANTA FÉ RAILROAD
See Chicago ablaze—and help fight the great fire.	Sail around the Lakes on an authentic sternwheeler.	Paddle an Indian war canoe through the Great Lakes.	See real American Indians at home in their tepees.	Ride the Iron Horse through Freedomland to San Francisco.

SATELLITE CITY: THE FUTURE

SATELLITE CITY TURNPIKE	SPACE ROVER	BLAST-OFF	MOVING LAKE WALK	SPECIAL EXHIBITS
Drive a modern sports car over the road of the future.	A round-the-Americas cruise through stratospheric space.	See authentic Cape Canaveral space rocket launching.	Cross Satellite City Lake on a traveling sidewalk.	See the wonders of modern science and modern industry.

NEW ORLEANS: MARDI GRAS

CIVIL WAR	BUCCANEERS	DANNY THE DRAGON	KANDY KANE LANE	TORNADO ADVENTURE	CRYSTAL MAZE	SPIN-A-TOP
Ride through cross-fire on authentic battlefields.	Take part in thrilling pirate adventure.	A fantastic ride on the dragon's back.	Youngsters can see toys galore, children's rides.	Whirl in the eye of a wild tornado.	A baffling glass house of mirrors.	You spin in tops that turn on spinning tables.

THE GREAT PLAINS: 1803-1900

FORT CAVALRY	PONY EXPRESS	FORT CAVALRY STAGE LINE	CAVALRY RIFLES	BORDEN'S FARM	HORSE-DRAWN STATION WAGONS	MULE-GO-ROUND
Cavalry stockade of Indian-fighting days in the West.	Swift riders carry your letters to the Old Southwest.	The western stage coach takes you past buffaloes and bad men.	Frontier shooting-gallery for marksmen of all ages.	See horses, sheep, pigs, poultry, growing corn—and Elsie the Cow.	An old-fashioned ride around Fort Cavalry and Borden's Farm.	Ride the merry-go-round drawn by western mules.

THE OLD SOUTHWEST: 1890

OPERA HOUSE AND SALOON	BURRO TRAIL	TUCSON MINING COMPANY	MINE CAVERNS	CASA LOCA	GUNFIGHT	TEXAS LONGHORNS
Soft drinks at the bar, western revue on stage.	Western mules carry you across desert trails.	Ride high over Freedomland in an overhead ore bucket.	See the mysterious world under the earth.	The house where everything stands on its head.	A gunslinger's ambush in Billy the Kid country.	See live Texas steers and the western wranglers.

SAN FRANCISCO: 1906

NORTHWEST FUR TRAPPER	CHINATOWN	BARBARY COAST	SEAL POOL	SAN FRANCISCO EARTHQUAKE	RAILROAD STATION	HORSE-DRAWN SURREYS
Board a trappers' bull boat for a thrill-packed river ride.	A corner of the Far East in America's Far West.	San Francisco's glittering entertainment district.	Watch the Pacific seals at play in 'Frisco Bay.	See the spectacular 'Frisco quake and fire of 1906.	The Santa Fé Railroad from Chicago stops here.	Take a leisurely drive to the Old Southwest.

This is the back cover of the 1960 guide, providing a snapshot of a brand new Freedomland with all the original attractions.

PONY EXPRESS!
Be there when the Pony Express comes pounding into the old Cavalry stockade! Post your own letter! You'll pick it up yourself when you get to Tucson!

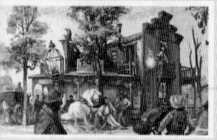

"OLD WEST"
"O. K. Pardner, it's a showdown!" Guns blaze! "Bullets" whiz past you! You're right smack in the middle of the wild and wooly West!

TORNADO RIDE
A howling Tornado roars across the Kansas prairie! See the awesome spectacle of homes and trees uprooted right before your eyes!

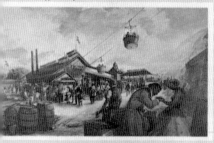

ORE BUCKET RIDE!
Soar through the air 70 feet above Freedomland! A breathtaking panoramic view! An unforgettable ride in this exciting new version of the old mine ore bucket!

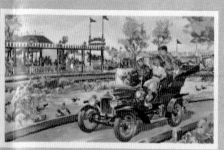

RIDE A 1901 CADILLAC!
Take the wheel and tour the country side of colonial New England! A family-fun outing past farms, homes and fishing villages, recreated to make a delightful trip for young and old!

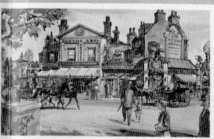

LITTLE OLD NEW YORK!
Stroll through the shops, the streets, the gaiety and atmosphere of New York as it was 100 years ago! Singing waiters, horse and buggies, costumes . . . policemen . . . everything is here to recapture an era!

PLANTATION RESTAURANT!
Gracious dining in a setting of the Old South. All across Freedomland you'll find interesting restaurants with menus and decor of their individual locales and time periods. The Steak House in Chicago, both Chinese and Italian restaurants in San Francisco, Mexican Restaurant in Tucson and the Dairy Restaurant in the Midwest. Also numerous snack bars prepared to serve you with a light bite in sparkling clean, cheerful surroundings.

Above is part of a Freedomland pre-opening flyer. History was clearly front and center as Freedomland

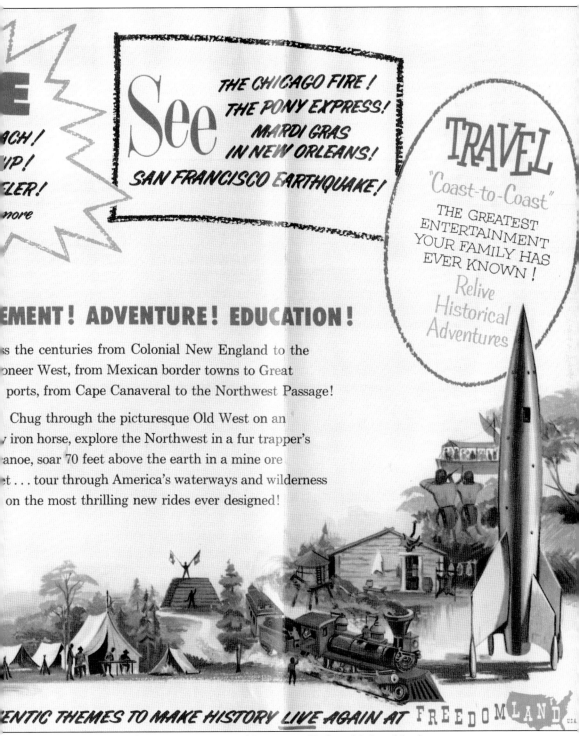

rolled out its first advertising campaign. (Courtesy of Robert McLaughlin.)

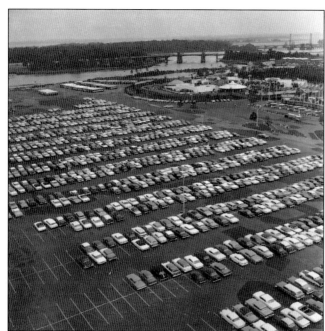

According to both the 1960 and 1962 souvenir guides, Freedomland's parking lot featured spaces for 7,200 cars. This did not include the employee lot. The Economic Appraisal of Freedomland report by Marco Engineering had set aside 80 acres to "accommodate the estimated in grounds crowd during average high days." An additional 20 acres would be set aside for "public vehicles, employees, and peak-day attendance."

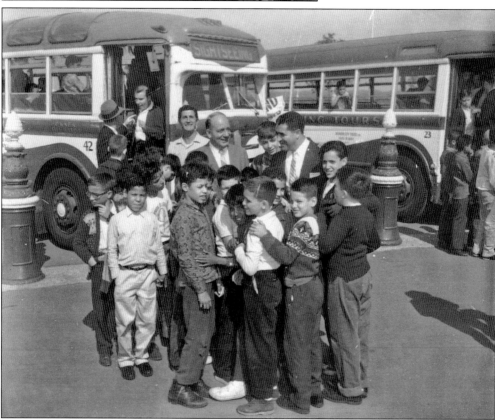

This is how lots of kids got to go to history-minded Freedomland: on a field trip. Here borough president Joseph F. Periconi (right) greets some happy campers.

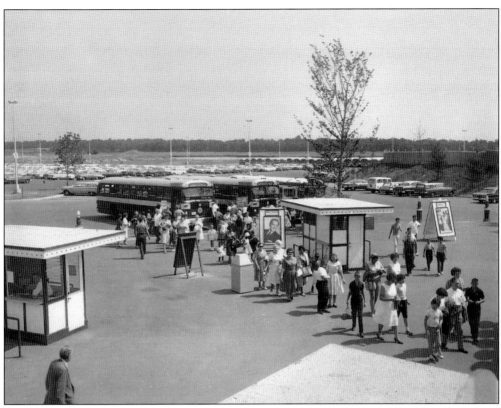

Another way of going to Freedomland was with a large group that would buy large blocks of admission tickets, like this group, Retail Clerks R.C.I.A. AFL-CIO.

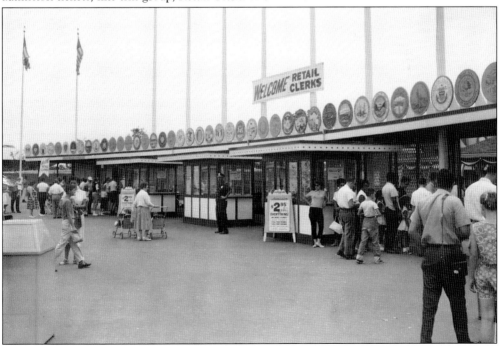

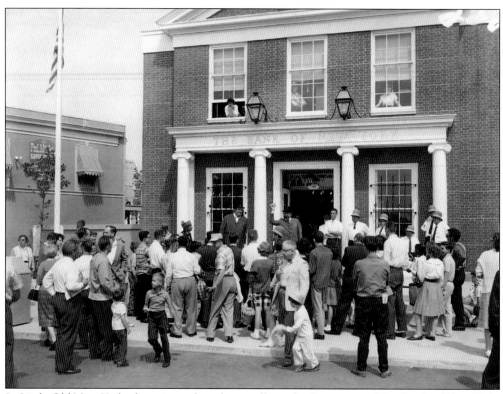

In Little Old New York, there is a political pep rally at the front steps of the Bank of New York. The park's branch was a true working bank for customers' use. In the pre-ATM, pre-debit card era, the Bank of New York provided park guests with convenient access to money, which they could then spend at the park. The bank's employees wore 1850s costumes, and according to the 1960 visitors guide, its customers could expect to see "a typical political pep rally of the period, with a spellbinding ward boss debating the burning issues of bygone times—such as better water in city wells."

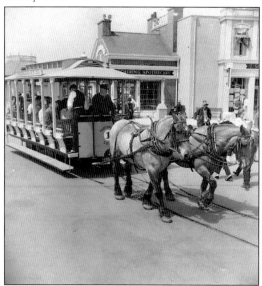

Like Disneyland's Main Street U.S.A., Little Old New York featured bygone forms of transportation, including an "old-fashioned horse-car," a horse-drawn surrey ("the kind with the fringe on top," explains 1960 guide, a reference to a popular song from the 1943 musical, *Oklahoma*), and even a horse-drawn trolley car—the sort of car displaced by the electric cars that necessitated the building of the first trolley parks, the predecessors of theme parks like Freedomland and Disneyland. According to the guide, the two horse-drawn cars had been specially built for Freedomland at a cost of $24,600. All three of these rides would carry guests "around Little Old New York and on to Chicago."

Right out of Disneyland's playbook were the daily parades performed at Freedomland. Whether they featured the park's own cast members and bands or invited marching bands or drum and bugle corps performing at Freedomland, these were exciting shows.

For the opening season, Little Old New York had no less than 13 corporate sponsors. Reportedly, rental space in Little Old New York was $25 per square foot and $20 per square foot for the rest of the park. Eastman Kodak Company's Photography Shop and Exhibit are shown here on Cortlandt Street.

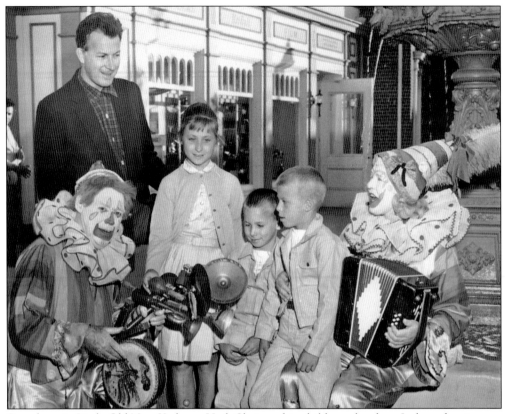

Seen here in Little Old New York are Herb Shriner; his children, daughter Indy and twin sons Wil and Kin; and two Freedomland clowns. Herb Shriner, besides being a dad, was a humorist, a radio personality, and a television host.

Where were the Keystone Cops at the real holdup? On Saturday evening, August 27, 1960, three armed men robbed Freedomland's cash control office of over $28,000. They made their getaway in a stolen boat, placed beside the Hutchinson River days earlier. Eventually the three were caught, and all three received prison sentences ranging from five to nine years.

Here a commercial is being shot in Little Old New York as the crew heads towards Chicago. Many of the special exhibits and shops run by participating corporations changed throughout the life of the park. Space does not allow them all to be listed. Here are a few from Little Old New York: the F. and M. Schaefer Brewing Company exhibit, the Borden Company Ice Cream Parlor, and the Lipton Inn by Thomas J. Lipton Inc.

American Oil Company sponsored the Horseless Carriage ride. In front of the attraction was a replica of an old filling station with antique pumps outside and an exhibit inside. There was also a talking gas pump. A cast member with a sight line to the kids and the pump would talk to them through a hidden speaker.

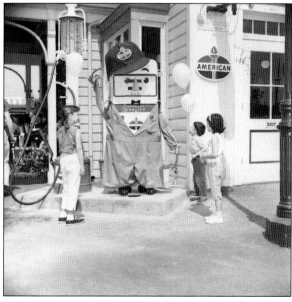

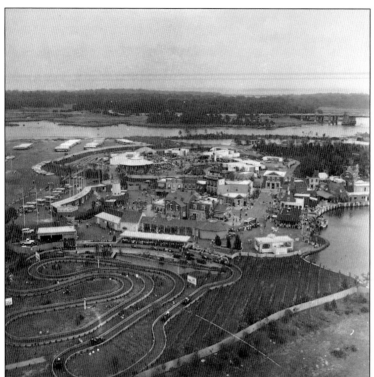

In this aerial view, the Horseless Carriage ride is on the left and Welch's Grape Vineyard is on the right, on the shores of Lake Ontario. In front of the vineyard, Welch's operated a grape juice stand. The vineyard and the Horseless Carriage ride were in the New England area of Freedomland.

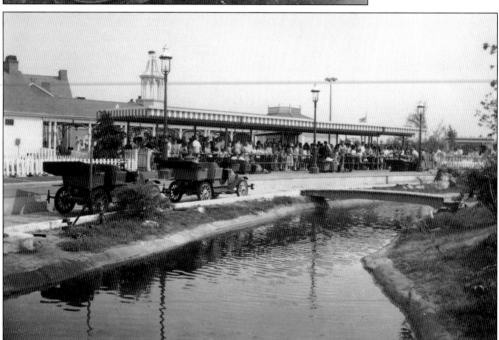

The Horseless Carriage ride was a hit for kids, who had to be over 4 feet tall to drive. Originally 30 replicas of the 1909 Cadillac were ordered from Arrow Development Company at a cost of $75,000. Ten more must have been added because both the 1960 and 1962 guides describe a total of 40 cars in the Horseless Carriage fleet.

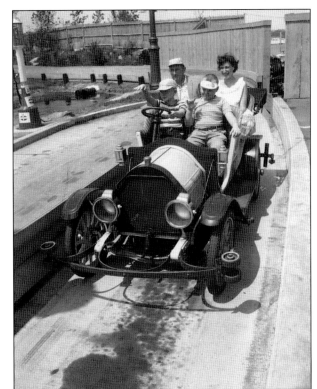

Excerpts from the 1960 guide describe the Horseless Carriage ride as "a real family touring car, seating four passengers, with a gasoline engine and an old-time klaxon horn. You'll drive your Caddy on a half-mile tour of the lovely New England countryside, past rippling streams and pleasant vineyards. A special governor on the engine keeps your car at a safe, comfortable speed."

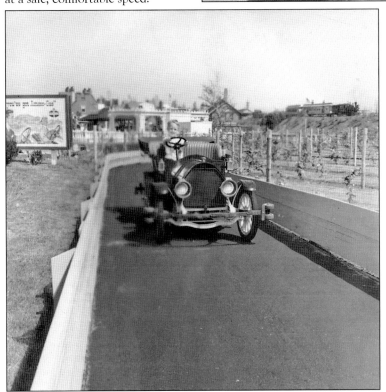

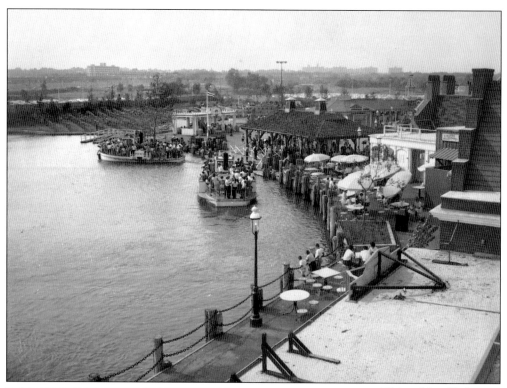

This is New York Harbor on Lake Erie with both harbor tugboats in view. Straight ahead is New England with the Welch's Grape Vineyard.

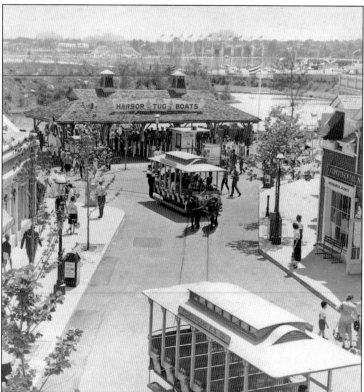

This view looks past the two horse-drawn streetcars towards the waiting area for the harbor tugboat ride. Little Old New York also featured a penny arcade.

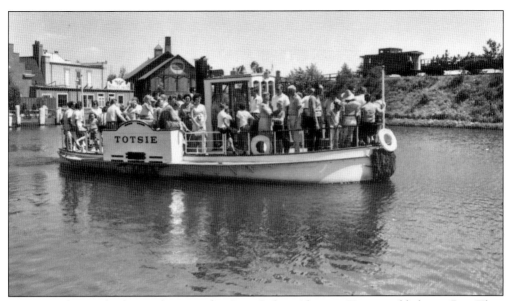

These are the two harbor tugboats in the Great Lakes. Above is *Totsie*, and below is *Pert*. They were built at the Minneford Yacht Yard in City Island, Bronx, New York. A record of purchase orders from February 29, 1960, has Freedomland paying $38,000 for two excursion tugboats. According to *This is Freedomland*, the 50-passenger boats offered guests "a trip over the Great Lakes, passing the Chicago waterfront, an Indian Village, war canoes, sternwheelers, and many other interesting things."

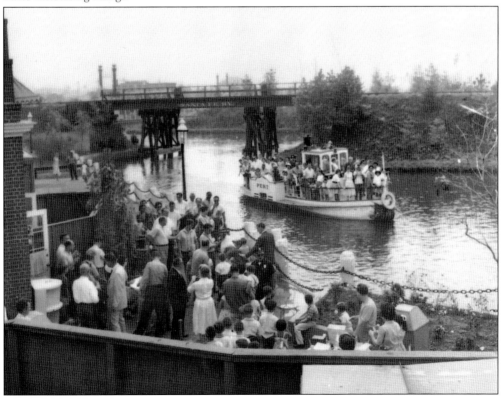

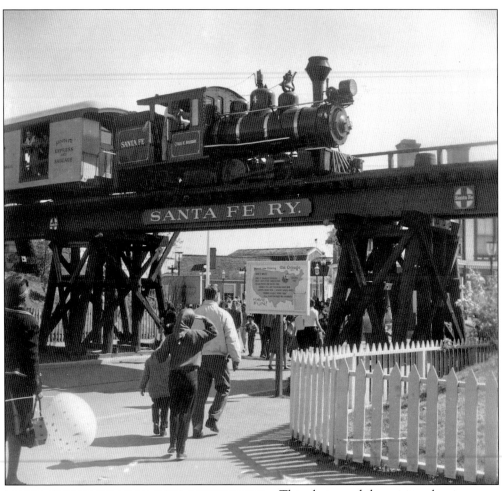

This photograph has visitors leaving Little Old New York and heading to Chicago. Above is one of the two trains that ran on the Santa Fe Railroad from Chicago to San Francisco and back on a circuitous route.

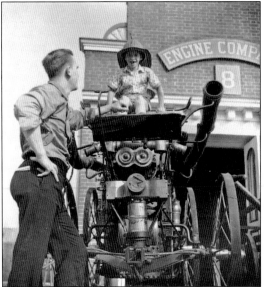

As visitors entered Chicago, on the left was the Fire House. How much fun is this boy having? The Fire House featured a hand pumper made in Tennessee in 1840.

Freedomland's designers came up with a winner with this attraction. What child would not like to play a fireman putting out a fire, even if it was a make believe one? According to *This is Freedomland*, "Each window in this building has its own gas burner with its own pilot. When the gas is turned on, the flames will go 7 feet high when there is no wind, but much higher with a wind. The Chicago Fire will be manually operated and about $35,000 worth of gas will be used each season."

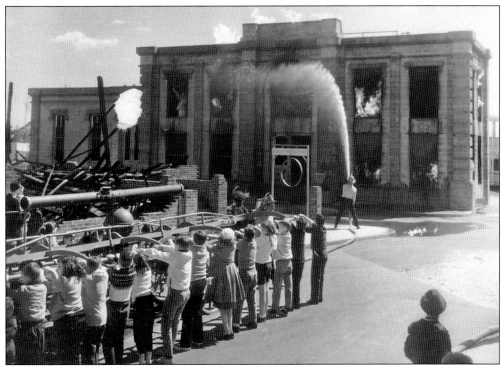

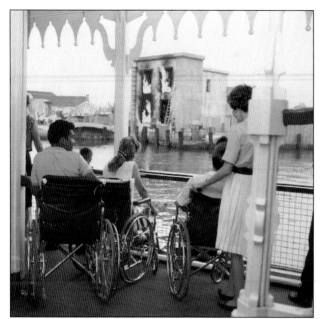

Looking out from one of the stern-wheelers at the Chicago Fire is a group of handicapped park guests. Freedomland was ahead of its time for accessibility throughout the park for all of its guests. Marco Engineering's *Economic Appraisal of Freedomland* noted that park guests would likely be distracted and "more attentive to the attractions than to the ground." Consequently, curbs could be hazardous. Furthermore, they represented "a particular hardship to people on wheelchairs or parents pushing children in strollers." Accordingly, the report explained, "Curbs will be avoided wherever possible in detail design."

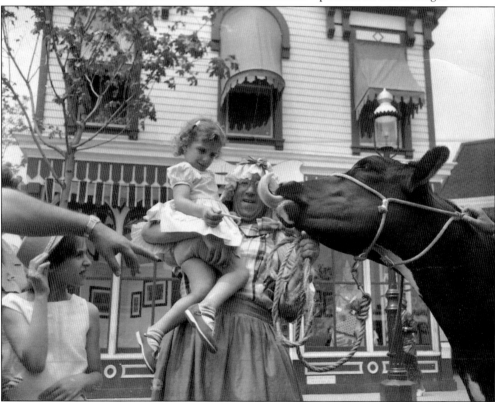

Mrs. O'Leary and her cow were regular stars in Chicago. Just down the street from the firehouse was Stockyards Restaurant, an open-fire steak house with seating for more than 300 at any one time. Stockyards was the largest restaurant in Freedomland. Hallmark Cards also had an exhibit and shop in Old Chicago.

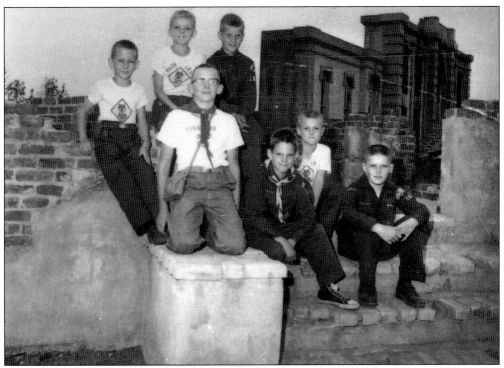

Posed in the ruins of the 1871 Chicago Fire and on the staircase of the Chicago Santa Fe Railroad station are two groups of Scouts. The kids seen here are representative of the thousands of boys and girls who came to Freedomland to have fun and to learn something about America's history at the same time.

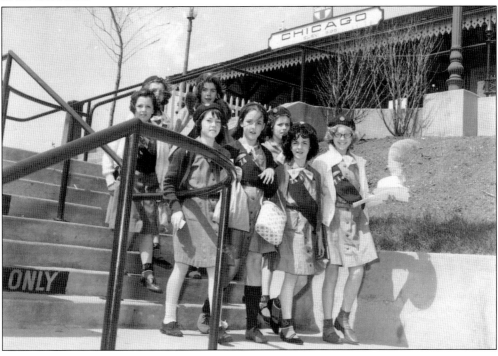

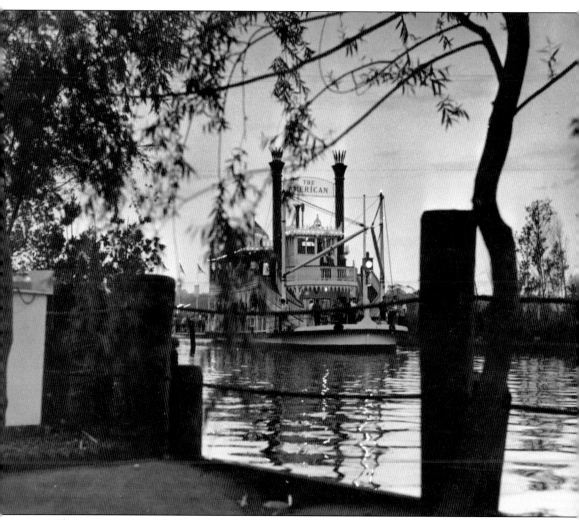

The *American* is profiled in this rare evening photograph out on the Great Lakes. Coincidentally, Disneyland's *Mark Twain* riverboat hull was built by the Todd Shipyards Corporation at their division in San Pedro, California, in 1955. Five years later, Todd Shipyards Corporation's Hoboken Division delivered two 110-foot stern-wheeler hulls to Freedomland.

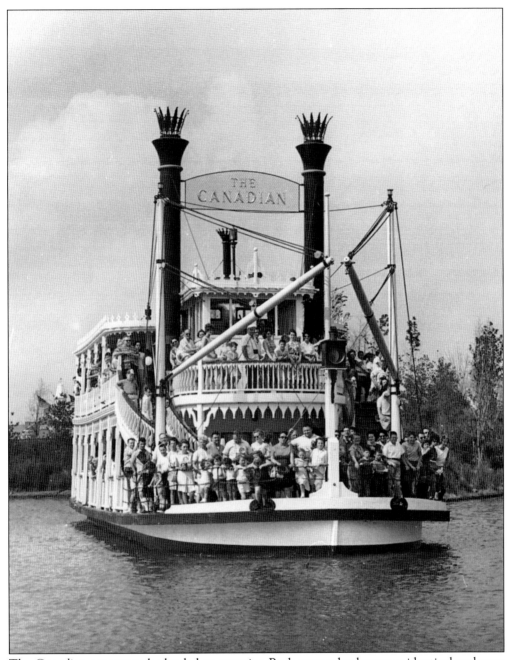

The *Canadian* appears to be loaded to capacity. Both stern-wheelers were identical and were designed to carry 400 guests each. The Great Lakes attraction was 10 acres in size and held 9.6 million gallons of water. According to Frank R. Adamo, the lakes would be drained into the Hutchinson River at the end of the season and refilled the following spring.

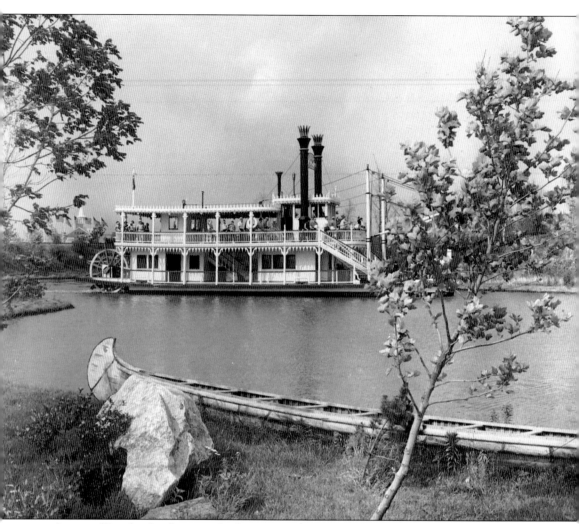

As one of Freedomland's stern-wheelers cruises the Great Lakes, it passes a Chippewa war canoe. The canoe attraction only lasted for the first two seasons. According to the 1960 guide, "Indian guides" would lead the passengers as they paddled their way past wooded islands and waterfalls. "A little further north," the guide promised, "there's a genuine Indian village, where you'll see real northwest Indians, making authentic Indian handicrafts in their own homes." The five 34-foot canoes were made in Maine for Freedomland at a cost of $4,700. They each carried 19 guests plus two guides.

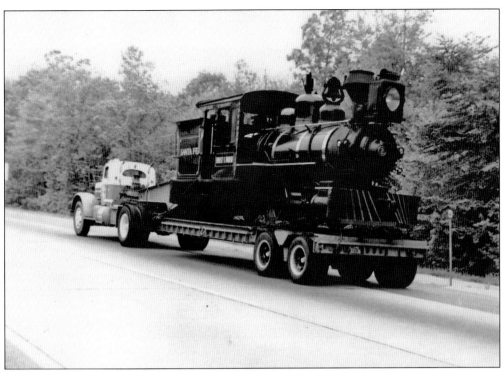

The above image shows Monson No. 3 in transit to Freedomland from Edaville Railroad in South Carver, Massachusetts, for the 1961 season. Edaville supplied both narrow-gauge (two-footer) locomotives and excursion cars for Freedomland's Santa Fe Railroad. All equipment was trucked back and forth for each season. The Santa Fe Railroad attraction was sponsored by the Atchison, Topeka, and Santa Fe Railway Company. (Courtesy of Walker Transportation Collection, Beverly, Massachusetts Historical Society.)

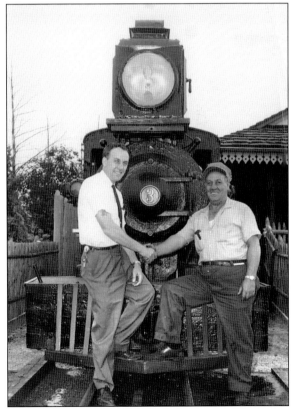

Frank R. Adamo is seen here with his father, John, in front of the Edaville Monson No. 3. According to train historian Richard W. Symmes, steam engines No. 3 and No. 4 came from the Vulcan Iron Works of Wilkes-Barre, Pennsylvania. They were built in 1914 and 1918 respectively, both for the Monson Railroad in Monson, Maine. John Adamo was one of the park's train engineers.

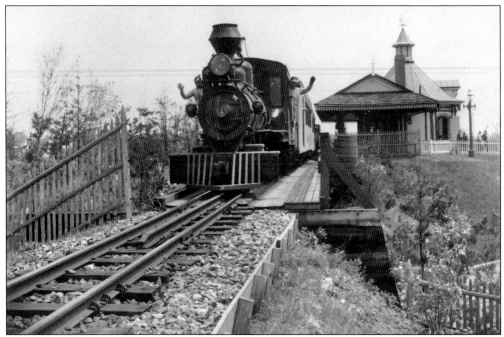

No. 4 is leaving the Santa Fe Railroad Chicago Station on its journey to San Francisco and back. Both No. 3 and No. 4 were sold by the Monson Railroad to a Rochester, New York, junk dealer in 1944. Ellis Atwood bought both locomotives in 1945 and took them to South Carver, Massachusetts. Monson Railroad had 6 miles of 2-foot track and used No. 3 and No. 4 to haul slate and occasionally passengers.

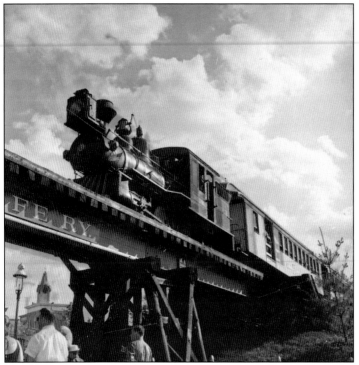

The Edaville equipment sent to Freedomland consisted of coach cars and, according to Richard W. Symmes, observation cars that were built at Edaville from parts of scrapped or spare railroad cars. The No. 3 Monson Locomotive was lettered "Ernest S. March," named for the president of the Santa Fe Railroad from 1957 to 1966. According to Symmes, the electricity for the train's headlight came from a turbo generator mounted on top of the steam-driven locomotive.

Freedomland's Santa Fe Railroad is about to depart the Chicago Station for San Francisco. During Freedomland's first season, when individual tickets were sold for all attractions, the cost to ride on the Santa Fe Railroad was 50¢ for adults and 35¢ for children.

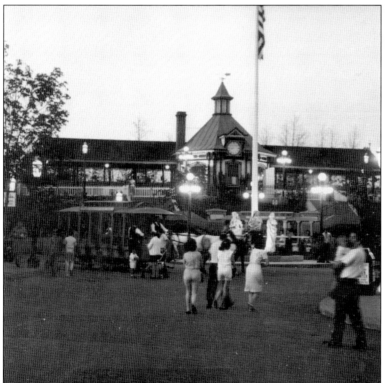

It is about 8:45 p.m. according to the signature clock at the Santa Fe Railroad Chicago Station. Freedomland's exterior lighting was designed to enhance the character of all of the themed areas of Freedomland after dark.

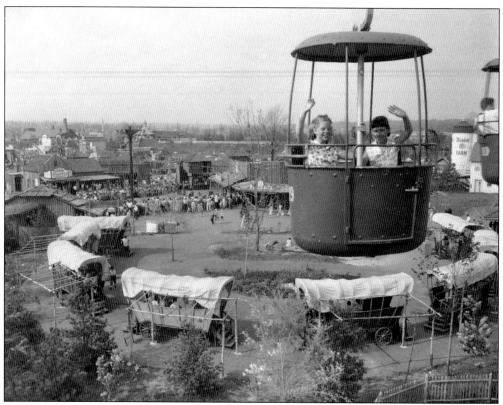

Fort Cavalry had one of the most unique dining areas in the park. According to *This is Freedomland*, Chuck Wagon Snacks would serve "special Western food" in the shelter of "covered wagons . . . forming a wagon train circle."

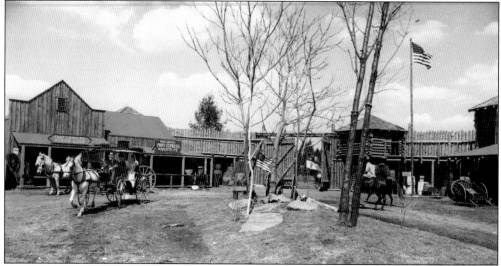

One of the services available at Fort Cavalry was the Pony Express Office. According to *This is Freedomland*, guests would be able to "mail a letter to themselves and watch it delivered to the Santa Fe area by Pony Express. While down in Santa Fe, they can pick up their mail at the Pony Express Office there." (Courtesy of Frank R. Adamo collection; photograph by Guy Gillette.)

Timmy (Jon Provost) from the popular *Lassie* television series takes aim at the still and moving targets at Cavalry Rifles. *This is Freedomland* promises, "This and our other gallery (Pirate Gun Gallery) are the newest things in shooting galleries. There will be a waterfall as well as water gags at this gallery."

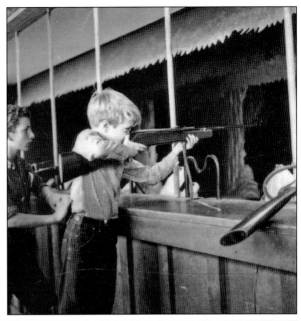

Piute Pete, with his famous Freedomland band, is conducting square dance lessons at Fort Cavalry for some of the older kids visiting the park. Piute Pete and his famous Freedomland band released a record set titled *A Child's Introduction to Square Dancing* in the early 1960s.

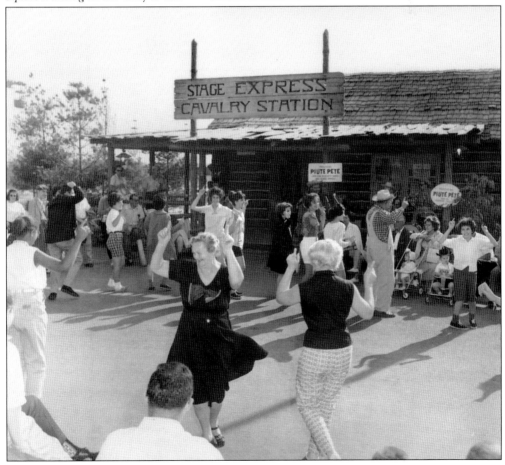

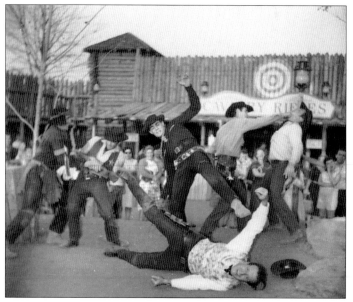

Freedomland was really a huge stage with shows performed throughout the park, including this one at Fort Cavalry. Freedomland's cast members seem to be having as much fun as the guests, playing "good guys and bad guys" all day and getting paid to do it. Also at Fort Cavalry were various themed western shops. Below, Digger O'Toole is measuring one of his new "customers."

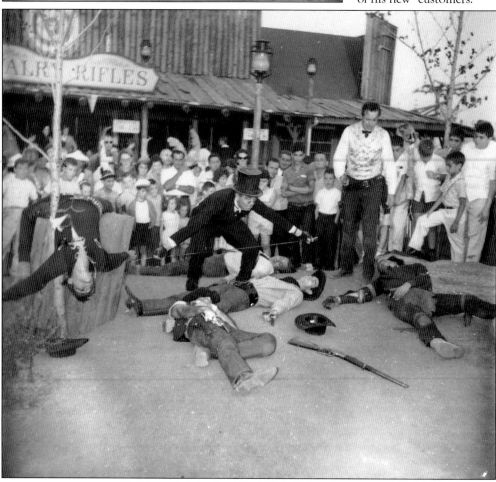

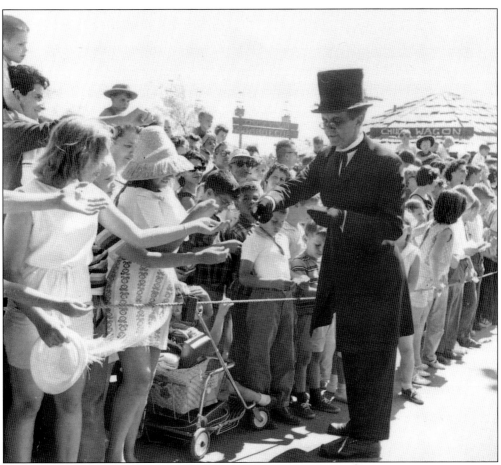

According to Frank R. Adamo, Freedomland character Digger O'Toole was very popular. The photograph above shows him handing out his card to guests at Fort Cavalry. To the rear are signs for the Chuck Wagon Snack Stand and Barbecue.

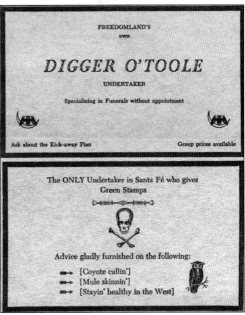

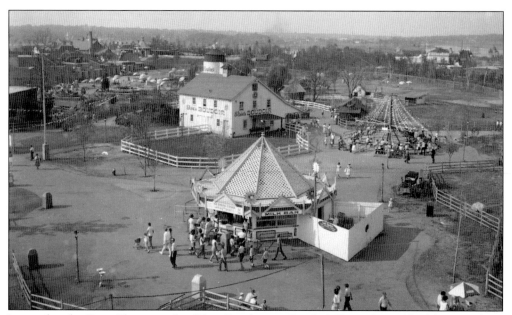

Located in the Great Plains, south of Fort Cavalry, was Borden's Farm. Several buildings made up the farm, including Borden's Milk Bar (lower center of photograph). Freedomland's designers did a great job conveying the story of America's heartland at this exhibit sponsored by the Borden Company. Besides the barn, the exhibit featured a working windmill, a corn crib, a haystack, a poultry house, a sheep fold, a pigpen, and farm animals.

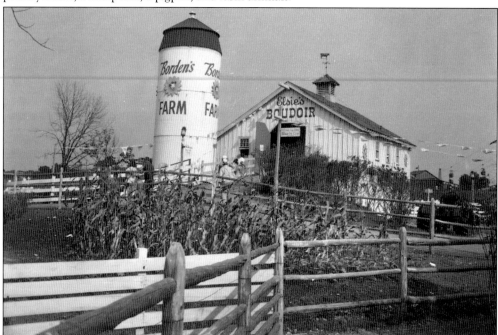

Corn is growing outside, but the star of the show is indoors. The 1960 guide states: "In the glistening white barn lives Elsie—the most famous cow in the world—with her beautiful twin calves. Surely they have the most unusual home a cow family ever had—a full-sized boudoir decorated magnificently with the finest of fabrics." (Elsie © the Borden Company.)

Guests observe Freedomland's animal handler, Louis Pasture, at a demonstration on the farm. Borden's Farm also had a petting zoo where guests could purchase food to feed the exhibit's four-legged residents. The 1960 guidebook also lists a country blacksmith shop.

A popular children's attraction at Borden's Farm was the Mule-Go-Round. This attraction was also at Boston's Pleasure Island. Since Magic Mountain (Denver), Pleasure Island, and Freedomland shared the same designers, many of the attractions were similar.

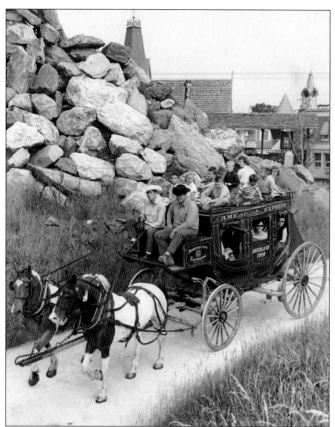

American Express sponsored the Great Plains Stagecoach ride. Starting at Fort Cavalry, park guests were transported through the Midwest and into the Rocky Mountains. Passengers could view a buffalo stockade and a herd of buffalo as the stagecoach headed west as far as the Santa Fe Railroad by San Francisco, and then back to Fort Cavalry. The Rocky Mountains were at least 50 feet high.

At the loading platform is one of the four Concord stagecoaches purchased from Gignac Wagon and Coach Company. At first, the coaches were pulled by teams of four horses. On June 24, 1960, a stagecoach overturned, injuring 10 guests; some required hospitalization. After the accident, the teams consisted of two horses.

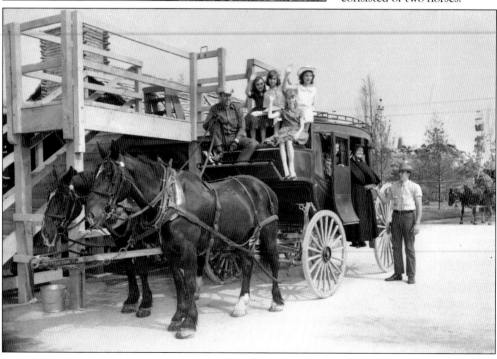

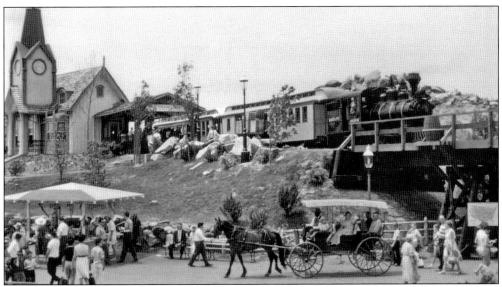

Guests found plenty to see and do when entering in San Francisco. Either on foot or coming in on the Santa Fe Railroad or a horse-drawn surrey, there was lots of excitement. Although Freedomland was massive, most guests would venture from Little Old New York to the west, through the south, and back to Little Old New York.

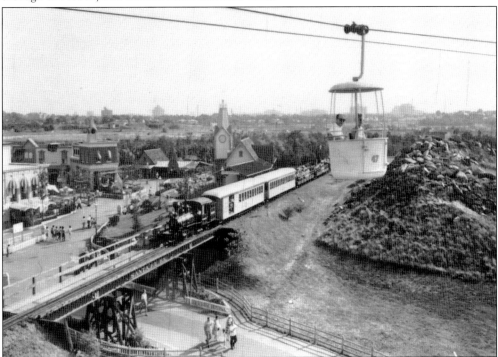

This is an excellent photograph from an "ore bucket" of Freedomland's San Francisco. The following is an excerpt from the 1960 guide about the dark ride, Earthquake: "On April 18, 1906, the ground fell from under San Francisco's feet. You will safely see the San Francisco earthquake and fire recreated in harrowing detail. You will ride past buckling sidewalks, open fissures and collapsing buildings. You will see houses slide sideways and crack in two, then burst into flames."

North of San Francisco was one of the most popular attractions, the Northwest Fur Trapper ride. Similar to Disney's Jungle Cruise, the attraction took guests on a narrated boat ride featuring special effects. In describing the ride for guests, the 1960 guidebook explains, "You shove off from Freedomland's San Francisco area, and sail along the Snake and Columbia Rivers. . . . Your trapper guide is armed, and he'll be using his gun. *Just in time!* . . . Thrill follows thrill, but every risk is a calculated one—calculated to give you the time of your life, controlled to bring you through in absolute safety. You'll relive every danger of the old trapping days, but you'll be harmed by none." Cast members considered being a Northwest Fur Trapper boat captain one of the coolest jobs in the park.

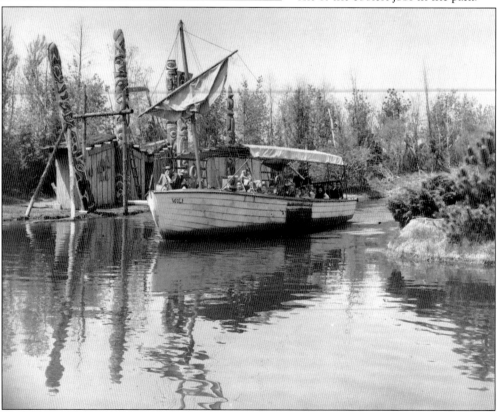

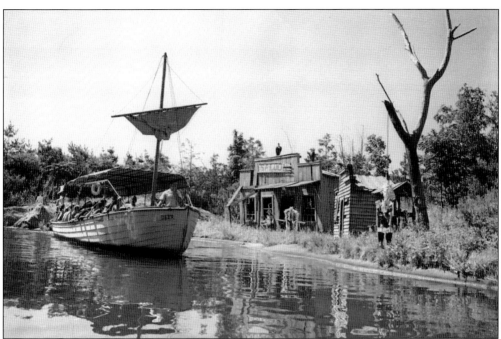

Nine trapper boats were built at the Minneford Yacht Yard at City Islands, Bronx, New York, for a total of $38,000. Winfield Hubbard's company, Special Effects, charged $2,395 for nine vintage guns and $1,475 for five cannons. C. V. Wood Jr. hired Special Effects for upgrades to Ohio's Cedar Point in the early 1960s. According to records from October 1, 1959, the total budget for the Northwest Fur Trapper attraction was $426,000. The cost of tickets for this ride during Freedomland's first season was 50¢ for adults and 35¢ for children.

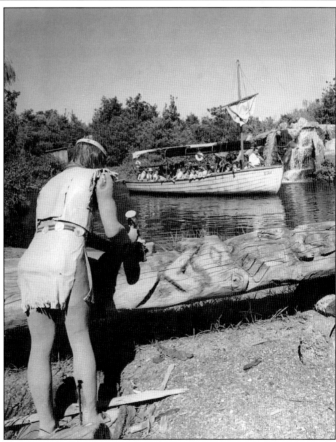

A model is featured in this photograph of Freedomland's San Francisco's Chinatown. According to Frank R. Adamo, several advertisements were shot inside the park during its five-year run.

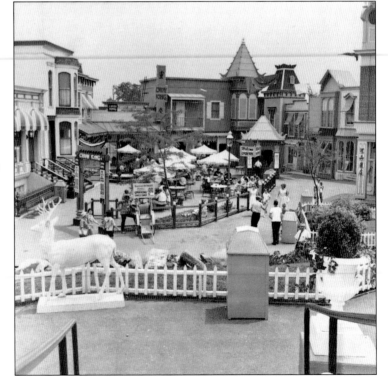

This is Freedomland describes San Francisco's Chinatown Grant Avenue Bazaar as featuring "many Chinese stores, which will sell all kinds of Chinese products and novelties. At Chung King Restaurant, right in the heart of Chinatown, you will be able to get some delicious Chinese food made famous by the Chung King Company."

According to *This is Freedomland*, the two Chinese junks seen bobbing here in the park's San Francisco Bay were built in Hong Kong. (Courtesy of David A. Clark.)

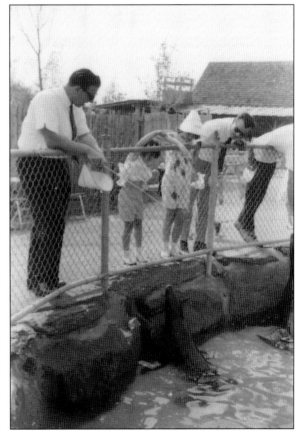

Leaning over the fence (center) is popular singer Julius La Rosa at the seal pool. Quite a few of the entertainers at Freedomland were photographed at various locations throughout the life of the park. Guests were able to purchase fish to feed the seals. Personnel would have to break up the ice in the pool for the seals during the winter months.

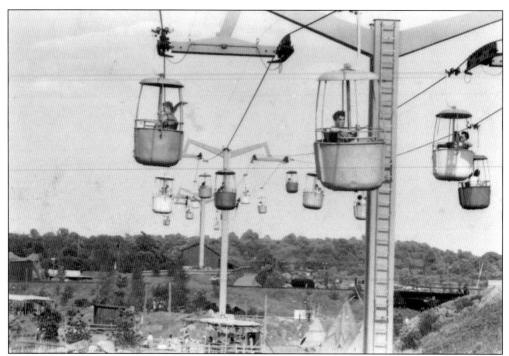

As shown in both photographs, guests would ride in 70-foot-high "ore buckets" of the Tucson Mining Company over the Rockies from the Old Southwest all the way to Freedomland's northern border and back. Guests could also disembark or enter at the northern platform after changes were made to the building during one of the upgrades to the park. *This is Freedomland* noted that its unique dual-cable sky ride was designed by the same Swiss ski-lift producer that had created similar rides at Disneyland, Pacific Ocean Park, and the Brussels's World's Fair. At maximum capacity, the attraction employed 64 buckets at once.

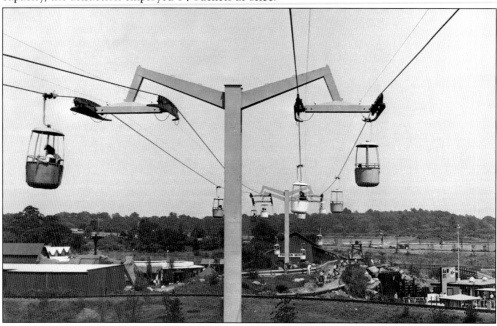

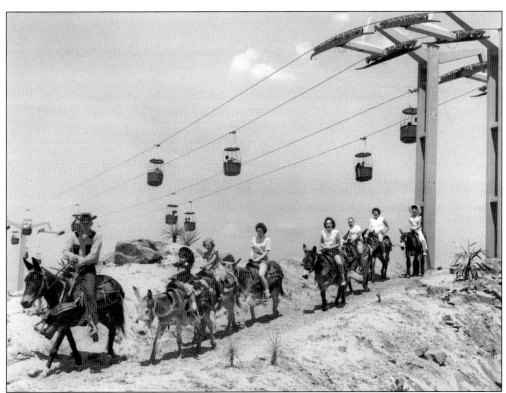

Another attraction in the Old Southwest was the Burro Trail. According to *This is Freedomland*, "live burros, united in teams of eight, will take the youngsters for a trip over hills into the Rocky Mountains. There will be 10 such teams." The building in the photograph at right was the Mine Caverns dark ride; the Borden Farm stands on the other side of the tracks.

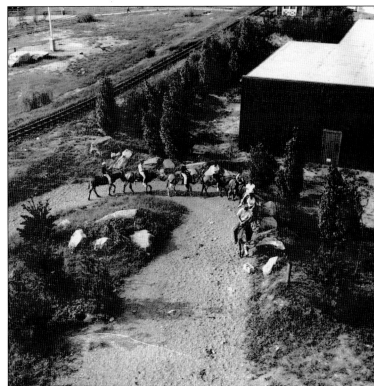

To gain access from San Francisco to the Old Southwest, guests walked through a tunnel right through the Rocky Mountains. Several attractions were located in this section of the park. One of them was the Casa Loca, which was a walk-through in a building filled with gravity defying gags. Similar to "mystery shacks" popular at various parks around the country, at Casa Loca, guests could witness water running uphill, pool balls running uphill, or bottles flying out a window. Shown posing here is singer Julius La Rosa.

In the image at right, guests have just survived a ride through the Mine Caverns attraction, touted by *This is Freedomland* as "a ride through caverns where you will see bats, stalagmites, stalactites, a three-headed dragon, singing winds, an echo chamber, waterfalls, etc." The train featured 14 cars, with four passengers to each car.

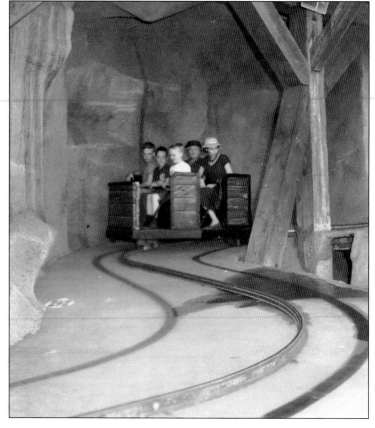

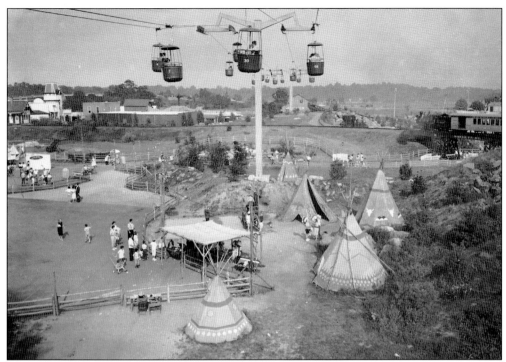

This photograph taken from the Tuscon Mining Company ore buckets shows a Native American village set up to the right of Borden's Farm. The small Santa Fe Railroad Station, which was not a stop, is shown in the upper left corner. Guests entered into San Francisco from the Great Plains under the railroad trestle on the right. The Old Southwest Opera House and Saloon can be seen behind the Santa Fe Station.

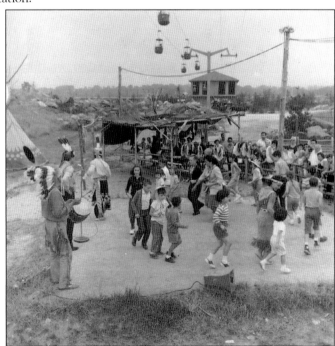

Freedomland hired Native Americans to portray its American Indian characters. In this photograph, little kids (and some big ones) are learning a Native American dance.

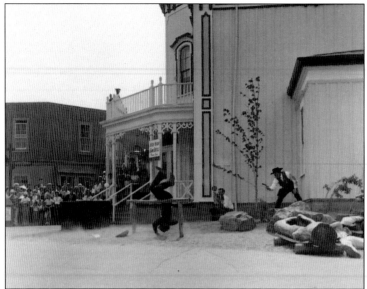

At the Old Southwest Opera House and Saloon there were two shows, the ones inside and the ones outdoors. In this photograph, some of the park's cast members are fighting it out at the "High Noon Gun Duel."

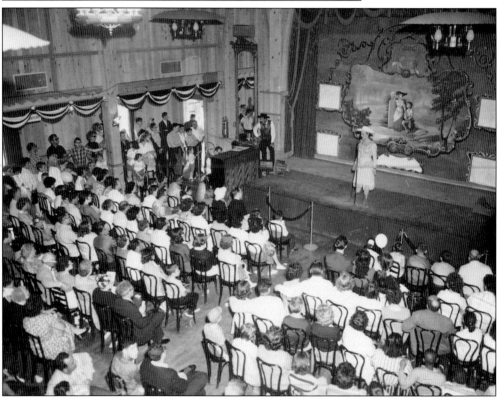

Freedomland hosted shows and various types of entertainment throughout the life of the park. The 1960 guide states, "The showplace of the Old Southwest is the Opera House and Saloon, where you can order soft drinks from the long bar as you sit and watch a real Western cabaret show, a half-hour of entertainment by a four-piece band, dancing girls, singers, and western comedians." The 1962 also guide states, "You'll see silent films with all the great stars of the past, and there'll be music, too."

How exciting it must have been for kids to experience the Wild West in Greater New York City! This little girl gets to hang out with a couple of cowboys. The Old Southwest Opera House and Saloon, sometimes called the Music Hall, was sponsored by Pepsi-Cola.

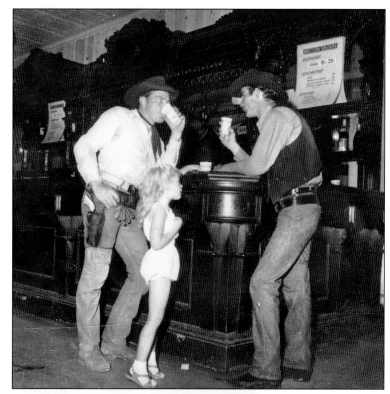

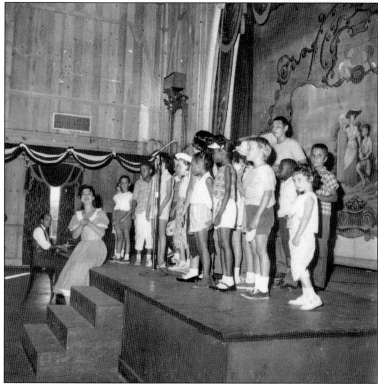

There was plenty of room on the stage for these happy guests acting as backup singers for Freedomland's saloon singer.

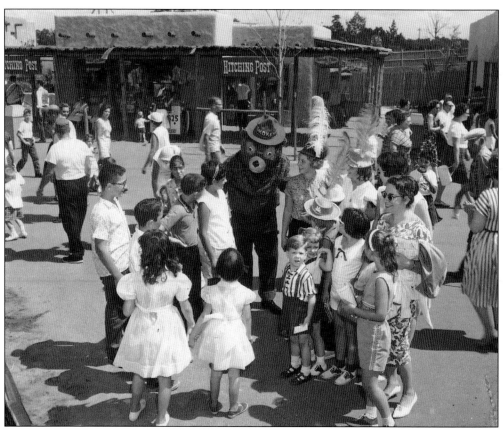

Seen here in front of the Hitching Post is visiting dignitary Smokey Bear.

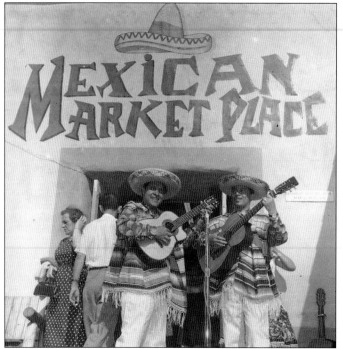

To round out the guest's Old Southwest experience, there was the Mexican Marketplace, along with live entertainment. There was also a Mexican restaurant sponsored by the Frito-Lay Company, and a snack stand.

Heading into New Orleans, guests had rides and a host of other attractions to experience. On the Buccaneer ride, guests would, according to *This is Freedomland*, "pass between two pirate ships blasting at each other and see many other phases of pirate life."

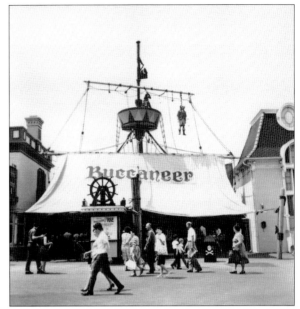

The pirate seen here at the Buccaneer attraction is Jimmy Valentine. Kodak set up 150 picture-taking posts throughout the park. This is one of them.

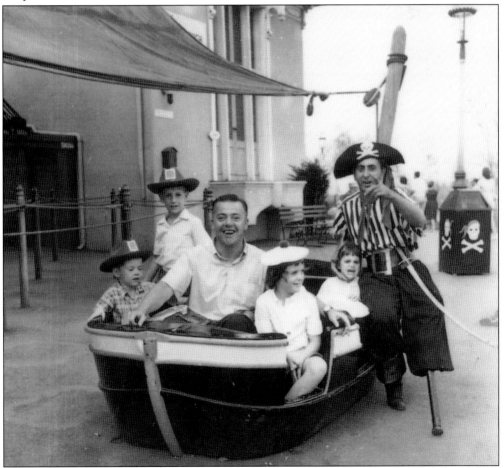

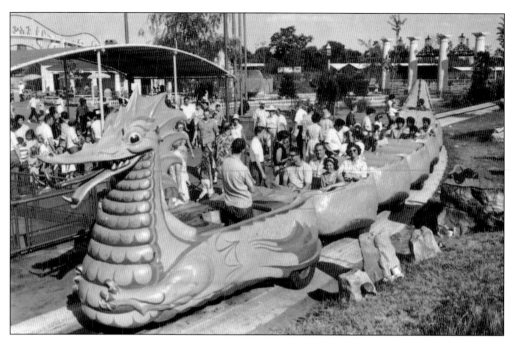

On Basin Street was the Danny the Dragon attraction. Shown in this photograph are guests loading onto one of the two 74-foot-long monsters who, according to the 1962 guide, "had a heart of gold." Also in this section of the park were the New Orleans and Plantation Restaurants, the Pirate Gun Shooting Gallery, and a snack and popcorn stand.

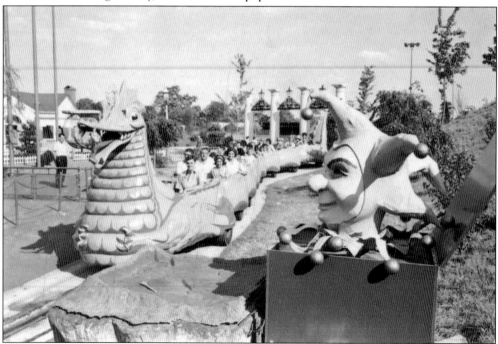

According to the 1962 guide, "All your favorite storybook characters will live again along the way as Danny carries you through glorious gardens." Each of the two dragons had a capacity for 48 passengers. They were built by Arrow Development Company for $47,080.

Guests are just coming out of the Tornado Dark Ride. *This is Freedomland* claimed that guests would "see a tornado approaching, ride through the storm, and then see all the effects of the tornado." The woman in the back (left) looks it.

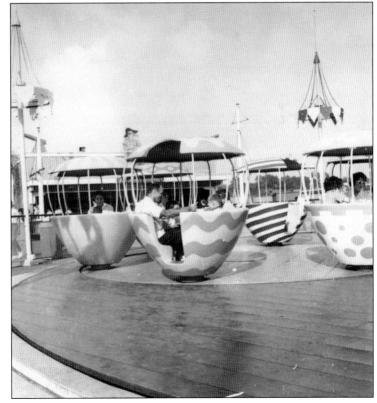

On Bourbon Street was a Spin-a-Top. *This is Freedomland* states, "18 spinning tops will take our guests on this whirl and twirl ride. There will be three turntables with six tops on each table. Our guests will be spinning in all directions on this ride."

This is Freedomland explained that the Civil War attraction would provide guests with, "a ride through the battle zones of the Civil War, past the forts, trenches, and blockhouses of the Union and Confederate armies, then through the raging gunfire of the armies." At the end of the attraction, guests could witness Lee and Grant together after the war.

Though guests originally rode in nine horse-drawn "correspondents' wagons" (above) seating 27 people each, the photograph at right shows that the horses were replaced by a tractor built to resemble a steam engine during the later years of the park.

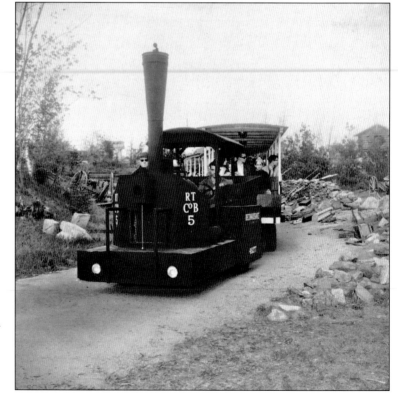

78

Two visitors from a foreign military are having a behind-the-scenes tour of the Civil War attraction. Some of Hollywood's most talented special effects people were hired by Marco Engineering to create these high-tech attractions.

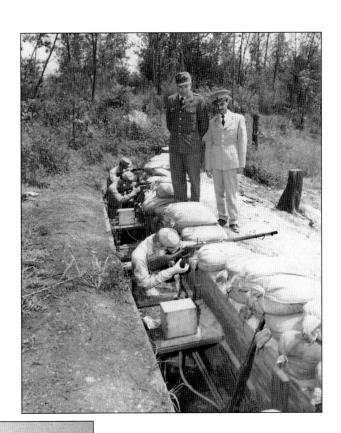

Charley Weaver (Cliff Arquette) was featured on the official Freedomland album singing "Danny the Dragon." He opened the Charley Weaver Museum of the Civil War in Gettysburg, Pennsylvania, in the 1950s (currently the National Soldiers Museum). He also operated a Civil War museum at Freedomland, where guests could be photographed in a Civil War uniform.

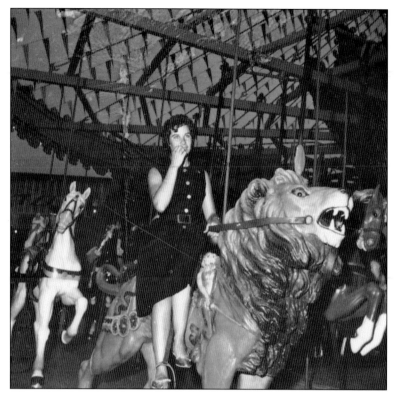

Freedomland purchased the King Rex Carousel from W. F. Rankin for $3,500. *This is Freedomland* states: "Named after the King of Mardi Gras, this carousel has 72 moving animals plus 3 stationary coaches and is 54 feet in diameter and 132 feet around."

Directly ahead here is the King Rex Carousel. To the right is the Crystal Maze. *This is Freedomland* states, "In a glass-walled hexagon shape, this building consists of a maze of glass and mirrors, including distortion mirrors, which attempt to outsmart our guests as they try to find their way through this maze."

During the first season, here in Satellite City, guests would ride on a moving sidewalk over a shallow reflecting pool that stretched throughout this area and on to the Space Ship. In 1961, the reflecting pool was built over and the Moon Bowl Dance Floor was constructed. The moving sidewalk, however, lasted for the life of the park.

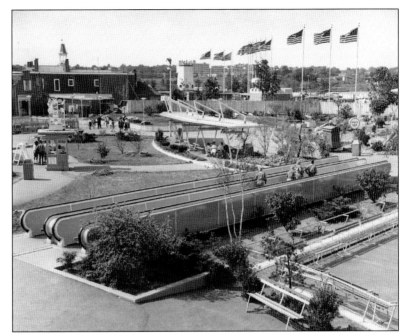

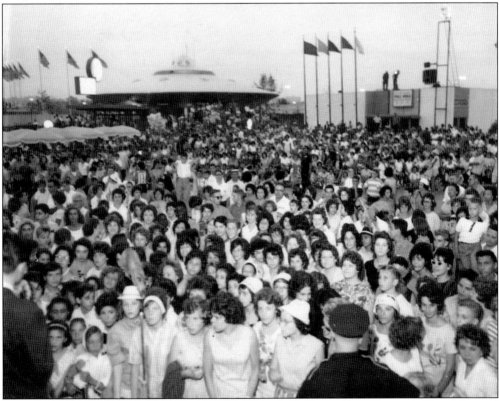

At the top of this photograph in Satellite City is Braniff International Airway's "Space Rover," a simulated spaceship ride around the earth, also known in other years as the Space Ship. The building on the right is the Science and Industry Exhibit.

The 1962 guide describes the Blast-Off Bunker attraction as bringing "All the tense excitement of Cape Canaveral" within an "authentic reproduction of the blockhouse at America's missile test center." Guests would watch expert technicians and scientists prepare the space capsule for the attempt to orbit an astronaut around the earth: "As the countdown nears zero, you'll move to an observation bay where you'll see the magnificent missile poised on the launching pad. Suddenly, the engines ignite, the missile lifts slowly and gracefully off the pad and thunders towards outer space. You'll follow the rocket's course on a tracking screen inside the blockhouse. And you'll be right on the scene when Navy ships recover the capsule and its heroic passenger."

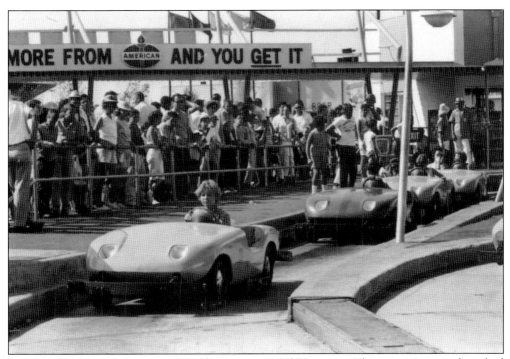

Satellite City Turnpike was sponsored by American Oil Company. This attraction was described in *This is Freedomland*: "Those who are four feet and taller will be able to drive the sports car of the future over a futuristic freeway, which will take them all around Satellite City. There will be 40 cars, 20 on each of the two separate roadbeds."

Arrow Development Company built the Turnpike's 40 gasoline-driven freeway cars for $80,000. The Satellite City Snack Stand and a soft drink bar also operated in this section of the park. Guests could continue right back to Little Old New York from Satellite City.

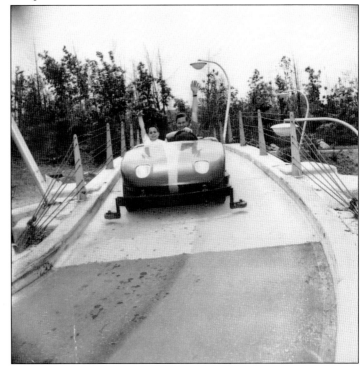

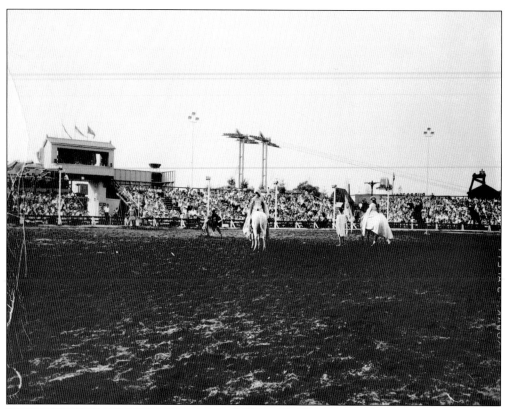

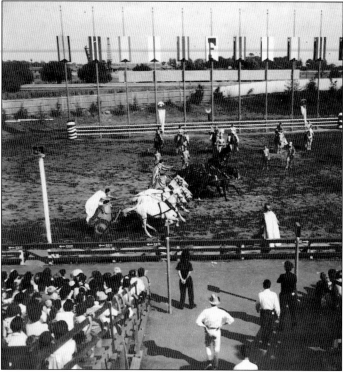

The massive Hollywood Arena was built for the opening of Freedomland's second season on June 10, 1961. The arena was south of San Francisco on land set aside for a future movie lot attraction, according to Freedomland's original master plot plan. For the 1961 season only, the show "Colossus," produced by Freedomland, was presented in the brand-new arena. "Colossus" was described by a park publication as featuring "daredevil chariot races, gladiators in mortal combat, King Arthur's Knights in a jousting tournament, the Three Musketeers, and the Charge of the Bengal Lancers."

Sharing the Hollywood Arena with "Colossus" was a host of local big bands like Lionel Hampton and favorite local television stars such as Joe Bolton, Claude Kirchner, and Chuck McCann. On Saturdays, there was date night with Clay Cole, and on Sundays guests joined Merv Griffin's Sing-for-All. Pictured here are a gladiator, two young guests, and their four-legged friend for a photograph opportunity in the Hollywood Arena.

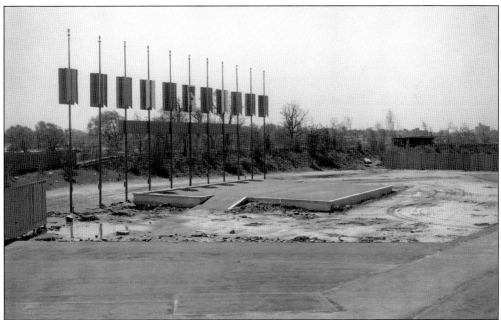

For the 1962 season at the Hollywood Arena, a permanent stage was built (under construction in this photograph) with a larger dance area. The flagpoles had the letters F-R-E-E-D-O-M-L-A-N-D facing towards the Hutchinson River Parkway. An A&W root beer stand was built just outside the entrance to the Hollywood Arena.

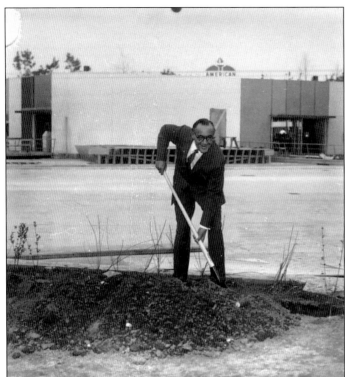

Early into the 1961 season, Benny Goodman was asked to perform at the new Hollywood Arena. According to Frank R. Adamo, Goodman did not believe that the dance arena was large enough. Goodman convinced management to build a larger dance floor. That is where the Moon Bowl came from. In this photograph, Benny Goodman is breaking ground for a photograph opportunity in Satellite City, the new home of the Moon Bowl.

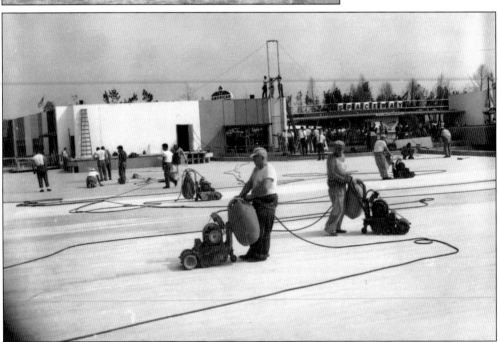

This photograph is not showing a floor sanders' convention; it is the new Moon Bowl, pictured early in the 1961 season. A total of 15,000 square feet of hardwood flooring was installed. The platform for the new stage is just in front of the exhibit building. To the right is the entrance to the Satellite City Turnpike.

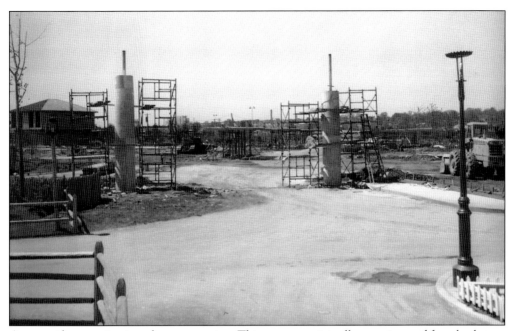

A new midway section is under construction. This area was originally a service road from backstage facilities into the park. This photograph is looking at the new entrance area from the Chicago area of Freedomland. The Tucson Mining Company tension house is to the left.

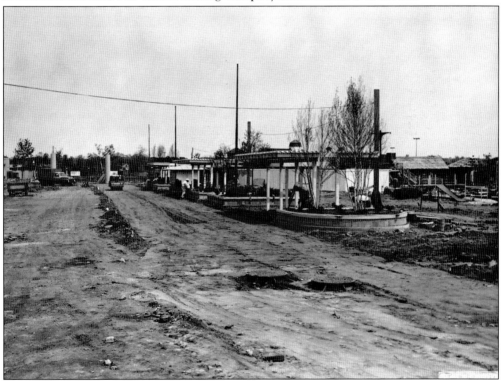

This construction photograph looks from inside the midway towards the new entrance. Reportedly, $1 million was spent on upgrades for the park's upcoming third season.

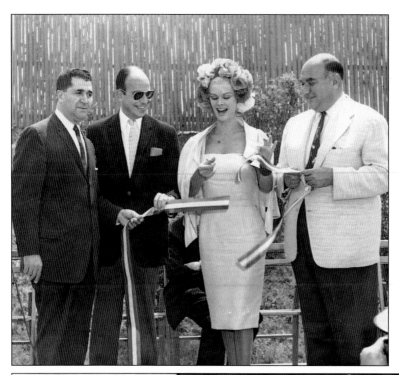

On Saturday May 26, 1962, Freedomland held a ribbon-cutting ceremony on opening day to celebrate the new upgrades to the park. Shown from left to right are Bronx borough president Joseph C. Periconi, William Zeckendorf Jr., Belgian-born movie actress Monique Van Vooren, and William Zeckendorf Sr., president and chairman of the board of Freedomland.

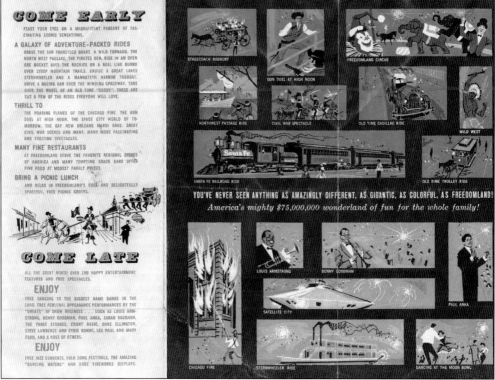

This flyer is from Freedomland's third season. The park was open for four weekends prior to the full seven-day-a-week operation starting on Friday, June 22, 1962. (Courtesy of Robert McLaughlin.)

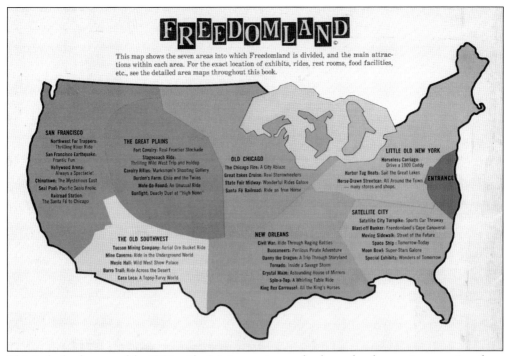

This is the back cover of the 1962 guide. It is interesting to check out the changes in attractions from the 1960 and 1962 guides. Most stayed the same, some were added, and some were discontinued.

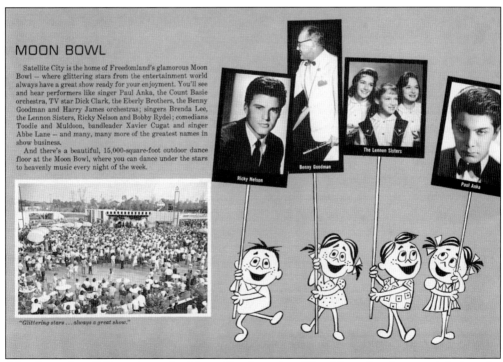

Also from the 1962 guide is the Moon Bowl section. The Moon Bowl opened during the 1961 season.

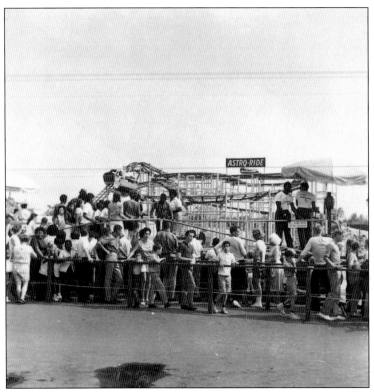

The Astro-Ride is featured in both photographs. The 1962 guide states, "Just outside Chicago is the colorful State Fair Midway, Freedomland's latest fun-filled feature. There's the exciting Astro-Ride, the Wiggle Worm, and many other wonderful rides." There was also a new dock for the Harbor Tugboats, a new loading tower for the Tuscon Mining Company ore buckets, and a new picnic area on the shores of the Great Lakes by the new tugboat dock.

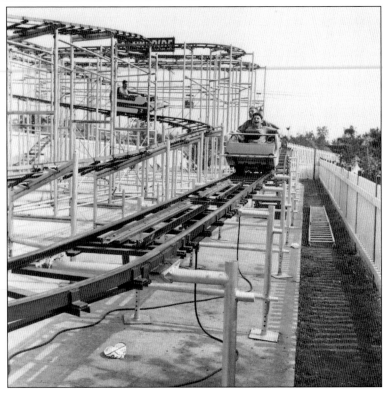

The new State Fair Midway was just one of Freedomland's attempts to attract more guests to the park. This photograph is the Wiggle Worm ride.

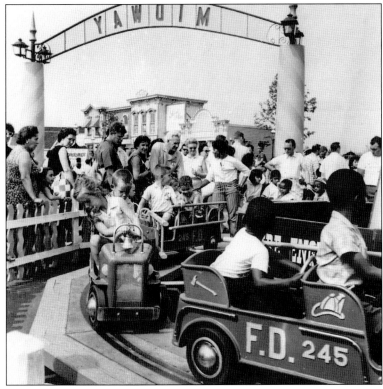

This photograph is of one of the children's rides located in the State Fair Midway. Old Chicago is in the background.

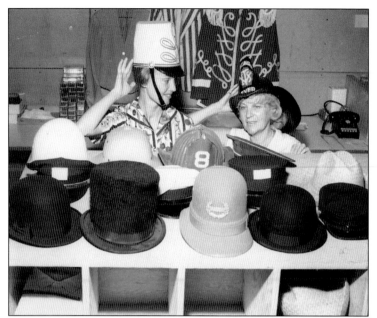

Freedomland was more than themed buildings and attractions. Its employees and cast members made Freedomland one of America's greatest theme parks. Try to identify which hat went to what section of Freedomland.

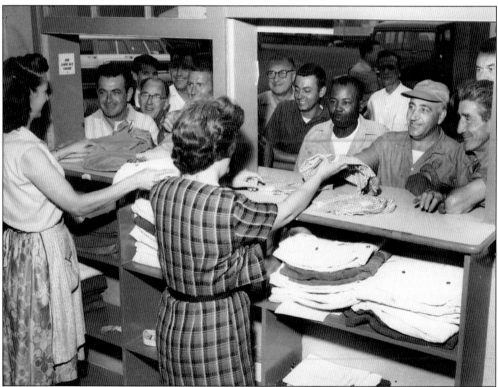

Outside the northern attractions were the support and maintenance facilities for Freedomland. This photograph is from the wardrobe building. This shift is picking up their uniforms. An excerpt from a June 27, 1960, *Billboard* article claimed that just after opening, Freedomland employed 1,200 people at an estimated $125,000 dollars a week, with an additional 1,800 staff members working for exhibitors.

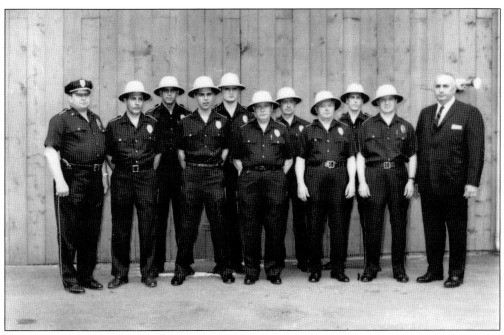

Some members of Freedomland's security force pose for a group photograph. On the right is head of security Mauro Contristano. *This is Freedomland* stated that the park employed a security manager, a fire chief, a fire lieutenant and 13 firemen, a security captain, four lieutenants, five sergeants, and 90 security officers."

Cast members are shown backstage at the wardrobe departments. There were thousands of costumes of all types and sizes from Keystone Cops to saloon dancers and spacemen and many more, including outfits for the cast members in this photograph.

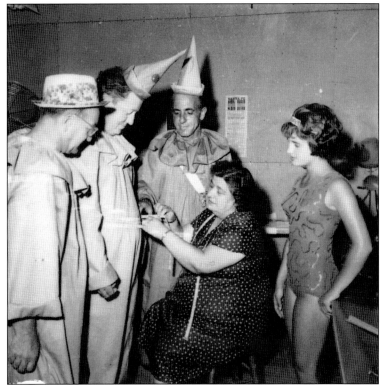

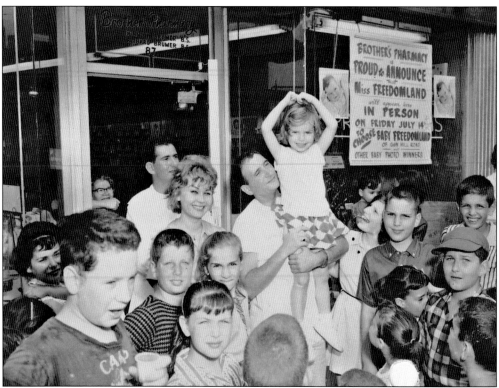

These photographs of "Baby Freedomland of Gun Hill Road" were taken in front of Stanley and Richard Brumer's Brothers' Pharmacy at 87 East Gun Hill Road in July 1961. According to Frank R. Adamo, this contest is an example of the many ways Freedomland reached out to the local community.

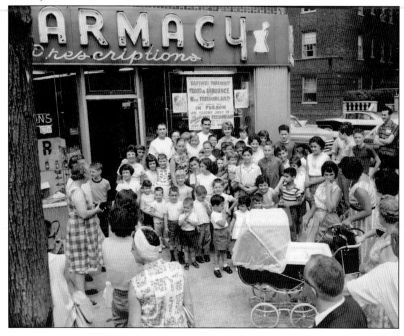

As shown in these undated early 1960s photographs, Freedomland advertised itself in surrounding communities. This Fireman's Day parade was held in Mamaroneck, New York, according to Frank R. Adamo, and shows a group of talented cast members who are riding one of the Overland Tour stagecoaches and wagon (photograph at right).

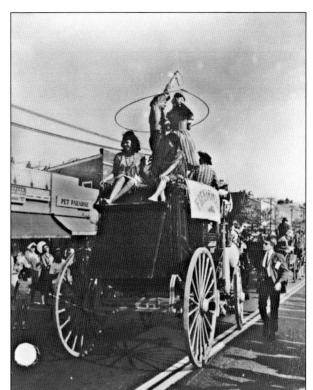

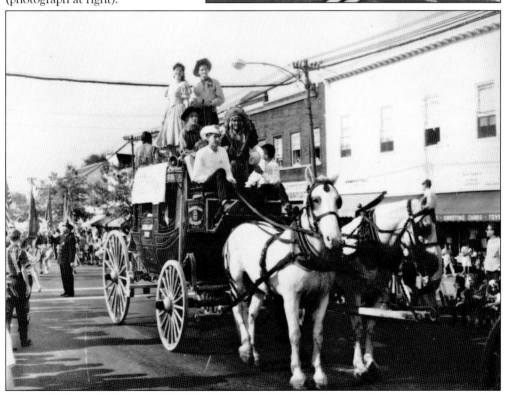

This photograph, taken on Fourteenth Street in Little Old New York, has Freedomland's extremely talented and well-liked musical director, Paul LaValle (second from left), with the Oom Pah band, one of the many musical units that LaValle oversaw throughout the park. Three stories tall, R. H. Macy's is just down the street.

This great photograph shows a gang of Freedomland cast members enjoying a backstage party. What a way to spend the summer!

Three

THE ENTERTAINERS

This chapter is dedicated to all the entertainers who performed at Freedomland, from costumed cast members and performers representing 200 years of America's history to a wide variety of local and national talent. An unbelievable amount of entertainment took place at Freedomland in just five short years. Starting out with just one stage in the Western Saloon, it did not take long for Freedomland to expand venues for a wide variety of entertainment for park guests. By the second season, the park had added the Hollywood Arena and the Moon Bowl.

Eventually the Space Ship was transformed into a venue for local DJ's to broadcast rock and roll, while just outside, some of America's premiere big dance bands and stars were playing to record crowds at the Moon Bowl. Meanwhile, the Western Saloon went from offering daily "can-can" style shows to presenting a variety of acts consisting of in-house and outside talent. The Hollywood Arena was modified for the third season with additional facilities.

Some local radio stations and talent that broadcasted from Freedomland included Dean Hunter and Mike Laurence from WMGM, Murray "The K" Kaufman from WINS, Phil McLean from WNEW, Paul Sherman and Bob Lewis from WINS, and B. Mitchell Reed and Dandy Dan Daniel from WMCA. WPIX-TV had broadcasts from Freedomland with Clay Cole.

Freedomland operated during years when big dance bands were running out of large venues to perform at and teens were attracted to the up-and-coming pop stars. Freedomland had entertainment for everybody, including daily themed in-house performances throughout the park.

In addition to the entertainers profiled in this chapter is an impressive list of entertainers that some lucky park guests got to see: Bernie Allen, Ray Anthony, Everly Brothers, Toody (Joe E. Ross) and Muldoon (Fred Gwynne) from *Car 54, Where Are You?*, Buster Crabbe, the Dick Clark Caravan of Stars (featuring Conway Twitty, Freddie Cannon, Bryan Hyland, DeeDee Sharp, and Buddy Morrow and his Orchestra), Jay and the Americans, Johnny Crawford, Danny Crystal (emcee), The Four Seasons, Frankie Fontaine, Connie Francis, Bobby Darin, Dion, Troy Donahue, The Dovells, Dave Garroway, Lesley Gore, Woody Herman, Jack Jones, Jimmy Jones, Kitty Kallen, Gene Krupa, Brenda Lee, Ralph Marterie, Martha and the Vandellas, Jackie Mason, Tex McCrary, The Mills Brothers, Patti Page, Della Reese, Debbie Reynolds, Johnnie Ray, Tommy Sands, Neil Sedaka, The Serendipity Singers, Allan Sherman, The Shirelles, and Bobby Vinton among others.

Posing for a group photograph are the Legionnaires Junior Drum and Bugle Corps from American Legion Post 1246, Oceanside, New York.

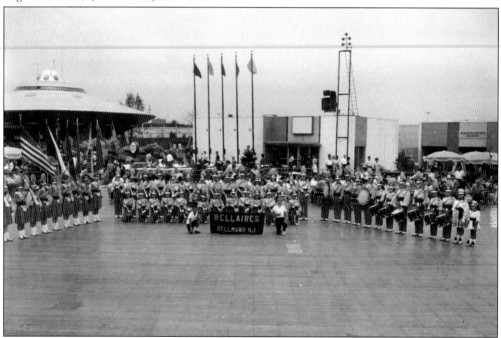

With the Space Ship behind them, the Bellaire Drum and Senior Bugle Corps from Bellmawr, New Jersey, pose at the Moon Bowl in the early 1960s for a group photograph.

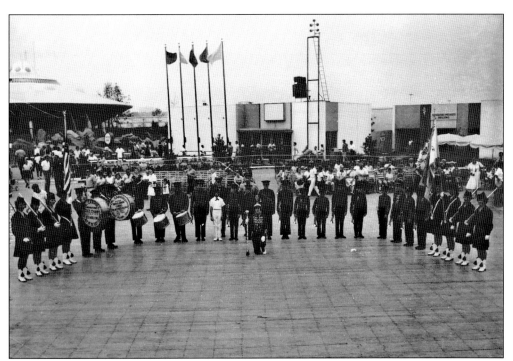

Lined up in formation for a group photograph on the Moon Bowl dance floor is the Corporal Carroll Junior Drum and Bugle Corps from West Haven, Connecticut.

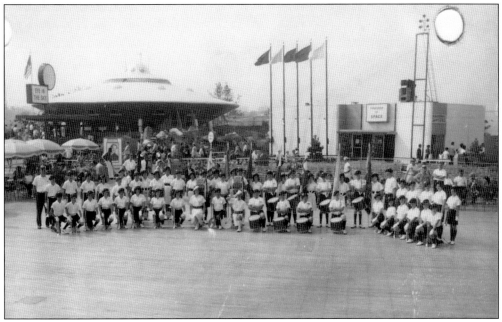

Lined up for their group photograph (early 1960s) are the St. Ann's Loyalaires Junior Drum and Bugle Corps from Bridgeport, Connecticut. Susan Mester, a former member of the PAL Cadets Junior Corps, notes that there were hundreds of junior and senior drum and bugle corps performing in the 1960s and 1970s nationwide. Susan's husband, Bob, and her cousin, John Donovan, were in the Loyalaires.

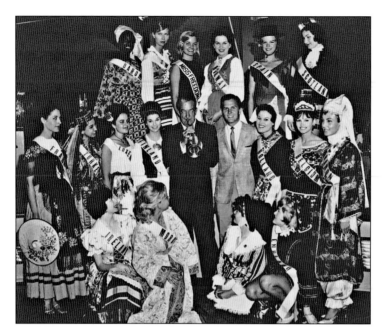

Standing with Miss Freedomland (third row, third from left) are Harry James and Pat Boone (center) and some of the contestants for a Miss World photograph opportunity at Freedomland's Moon Bowl.

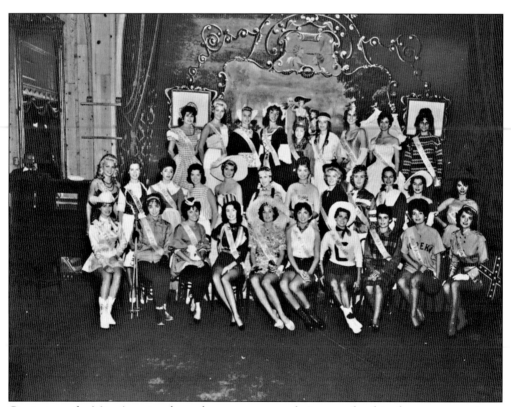

Contestants for Miss America dressed up to represent their states for this photo opportunity at the Opera House and Saloon located in the Old Southwest. Contests and one-of-a-kind events were held at Freedomland throughout the life of the park.

Upgrades to the Hollywood Arena were completed for Freedomland's third season. The 1962 guide stated, "From week to week you may see lady lion tamers, dancing elephants, colorful clowns, death-defying daredevils, aerial acts, amazing acrobats, thrilling trick-car exhibitions, or one of a dozen other big top specialties. You'll also see some of your favorite TV personalities—like Sonny Fox, Joe Bolton, Claude Kirschner or Fred Scott. Every night, the Hollywood Arena features the spectacle of the Dancing Waters. A fabulous array of fountains, brilliantly lit by every color in the spectrum, soars upward in time to music. The fluid rhythms, the changing shapes, the kaleidoscopic colors, surely provide one of the most unusual attractions in the park." Dancing Waters equipment is shown on the lower part of the photograph below.

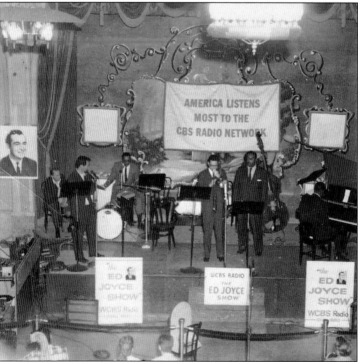

Live broadcasts from Freedomland by many of New York's radio personalities broadcast the excitement and entertainment within Freedomland to the world outside. Audiences in the New York City area and beyond would tune in, whether it was big band music from the Moon Bowl or disc jockeys spinning the latest rock and roll 45s from the Space Ship or the Old Southwest Opera House and Saloon. There was something for all audiences. In the photograph above, at center is longtime radio personality Jimmy Wallington for WNBC Radio at the Moon Bowl. At the Western Saloon there were live broadcasts like the one seen below, featuring the *Ed Joyce Show* on WCBS radio. The musicians are unidentified. Joyce would end up as President of CBS News.

Scott Muni, popular radio personality for almost 50 years in New York City, is shown here at the Western Saloon broadcasting for WABC. Local advertisements had Muni at the park in 1961 every Friday from 7:15 to 10:00 p.m.

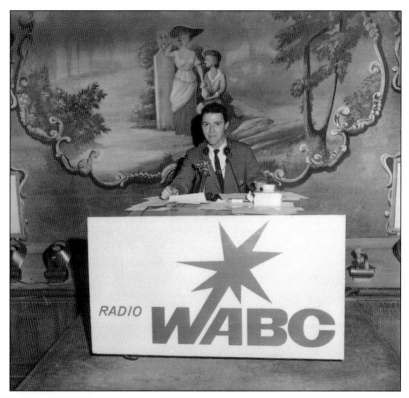

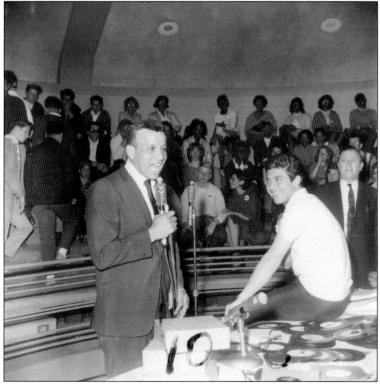

Disc jockey and radio personality Hal Jackson is interviewing Paul Anka in 1962 on WWRL at the Space Ship. According to the 1962 guide, "For a musical experience you'll never forget, step into the Space Ship, a remarkable sound chamber from which famous disc jockeys will be rebroadcasting your favorite music to thousands of radio listeners." The park was clearly changing with the times.

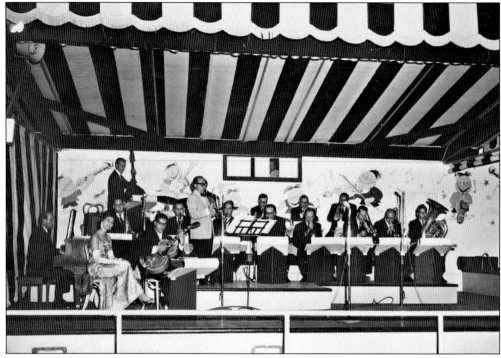

Paul LaValle, musical director for Freedomland, and his orchestra are performing at the Moon Bowl. The James Madison University library's Web page, which houses the LaValle collection, explains, "He studied music at Juilliard School of Music. He is remembered as a composer, conductor, arranger, and production director. In 1968, LaValle was appointed Director of Music and Principal Conductor of the Radio City Music Hall Orchestra where he remained for seven years." LaValle also conducted the City Service Band of America, which is now the Band of America in Atlanta.

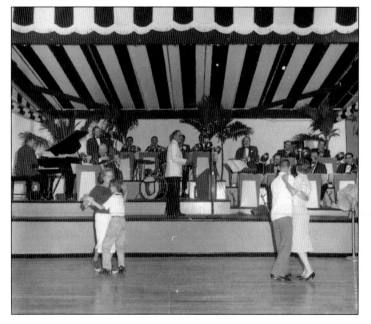

Benny Goodman (center) and his band are performing at the Moon Bowl. The "King of Swing" was an institution at Freedomland starting in 1961. The park was blessed to have such a talented musician and band leader. Goodman was honored with the Grammy Lifetime Achievement Award in 1986, the same year he passed away.

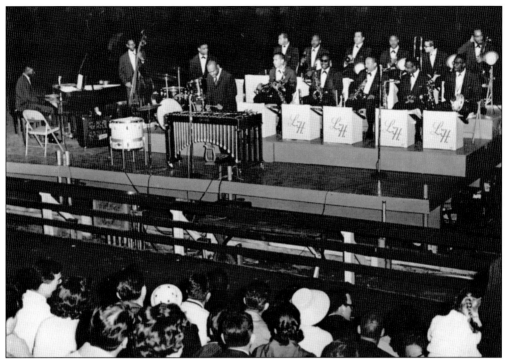

Lionel Hampton (at vibraphone) and his orchestra are performing at the Hollywood Arena in July 1961. Hampton continued to perform at Freedomland right up to the 1964 season, as did many of the big bands.

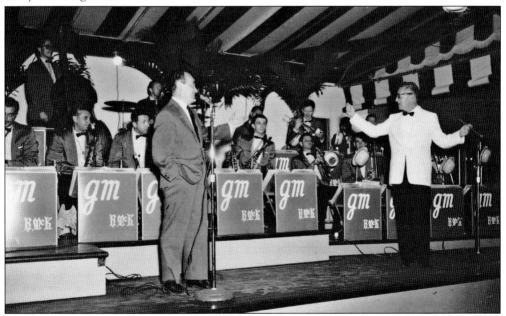

On stage at the Moon Bowl is Paul LaValle (left), musical director for Freedomland, and Ray McKinley (right). The Glen Miller Orchestra, under the direction of Ray McKinley, started playing the Moon Bowl in 1961. McKinley led the revived Glen Miller Band from 1956 to 1966. In addition to being a bandleader, McKinley was also an accomplished drummer.

Trumpeter Harry James (front, standing), with the Harry James Orchestra, is playing at the Moon Bowl (probably a rehearsal). James started his band in 1939 and by the 1950s was playing casino hotels in Las Vegas and Lake Tahoe. During World War II, James married World War II pin-up Betty Grable. He died at the age of 67 in 1983.

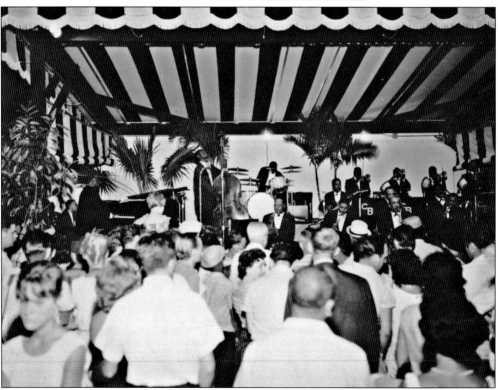

Count Basie (at piano) and his orchestra played the Moon Bowl from July 27 to August 1, 1961. *Billboard* reported in a related story on July 27, 1963, "Star performers booked for Freedomland stints this summer are Bobby Darin, Dion, and Count Basie, Patti Page, Paul Anka and others." At least one of Count Basie's 1963 shows at Freedomland was thought to have been broadcast live, coast-to-coast, from station WCBS.

On stage in 1961 at the Hollywood Arena are Les Paul and Mary Ford. (Between them is Paul LaValle, Freedomland's musical director.) This husband-and-wife team combined their many talents and ended up on radio and television. They sold millions of records. Les Paul was one of the early pioneers of the solid body electric guitar. His most famous customer is probably Paul McCartney.

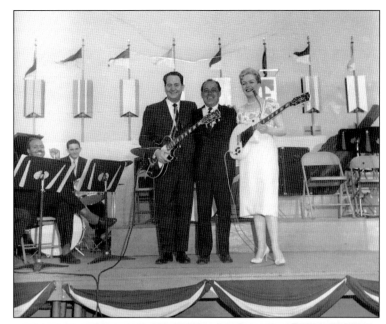

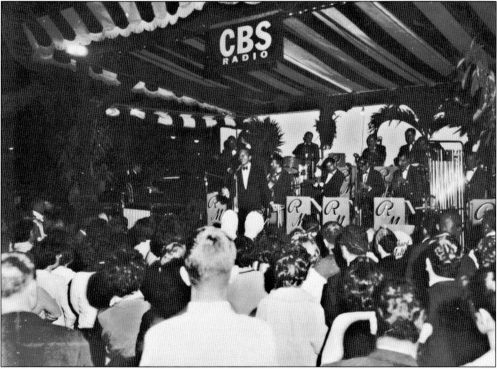

Andy Williams with Richard Maltby and his band performed at the Moon Bowl on Saturday and Sunday evenings September 16 and 17, 1961. One of the perks of Frank R. Adamo's job was meeting the stars. Adamo recalls having his photograph taken backstage with his wife, Fran; his daughter, Elizabeth; and Williams, among many others. Richard Maltby had a popular dance band. Accordingly to *Billboard*, September 29, 1962, the Richard Maltby Band was on tap at Freedomland September 15, 16, 22, and 23.

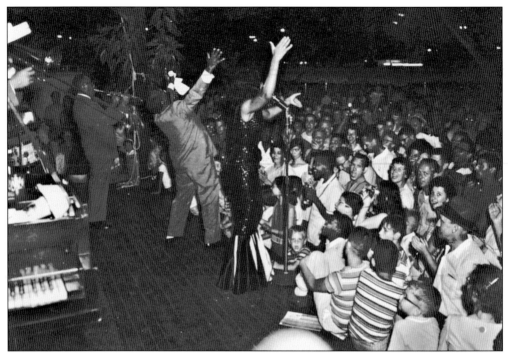

Louis Armstrong (center) is performing at the Moon Bowl. Local advertisements for Freedomland have him appearing for eight days starting on August 28, 1961. Armstrong was 60 years old in this photograph with an impressive career behind him and in front of him. Louis Armstrong died on July 6, 1971.

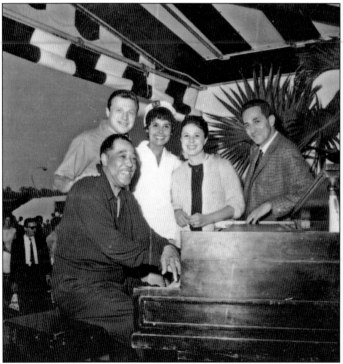

At the Moon Bowl for this photograph opportunity are, from left to right, Duke Ellington, Steve Lawrence, Lena Horne, Eydie Gorme, and Freedomland's director of show activities for the second season, Art Moss. Local advertising has Duke Ellington and his orchestra at the Moon Bowl August 22–27, 1961. Edward Kennedy (Duke) Ellington is buried at Woodlawn Cemetery in the Bronx. Lena Horne is absolutely stunning at 44 years old in this photograph.

What a lineup at the Moon Bowl! From August 15–21, 1961, Sarah Vaughan and the Jimmy Dorsey Orchestra with Lee Castle played. August 22–27 had Steve Lawrence and Eydie Gorme with Duke Ellington and his orchestra scheduled. Lawrence was born in Brooklyn, Gorme the Bronx. The lucky audience attending the Moon Bowl saw this talented couple fairly early in their career.

Tony Bennett with Warren Covington and his orchestra played at Satellite City's Moon Bowl to an energetic crowd. Local advertisements had them at the park July 1–7, 1963. Bennett was 36 years old in this photograph; Covington was 41. Today Bennett's career is still going strong. Warren Covington passed away in 1999 after a fascinating career that spanned decades of band music.

Paul Anka had a long relationship with Freedomland, as did his manager, Irvin Feld. Anka is seen here playing the Moon Bowl.

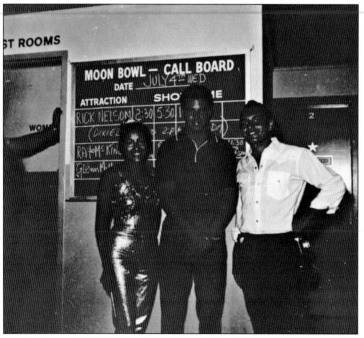

Ricky Nelson opened up for Pleasure Island's fourth season on June 22, 23, and 24, 1962. Nelson then went on to perform at Freedomland on July 3 and 4, 1962. Here is Ricky back stage at the Moon Bowl. Born in 1940, Ricky had already scored 20 Top 10 *Billboard* hits when he appeared at the park. He died December 31, 1985, in a plane crash in De Kalb, Texas.

Chubby Checker, backed up by Richard Maltby and his orchestra, took to the stage at the Moon Bowl on May 30, 1962. According to a "King of Twist" program signed by Checker to Frank R. Adamo's daughter, Elizabeth, "Chubby Checker was born Ernest Evans, October 3, 1941, to Mr. and Mrs. Raymond Evans in Philadelphia. He was a bouncing baby boy, and he has never stopped bouncing." (In truth, he was born in Spring Gulley, South Carolina.)

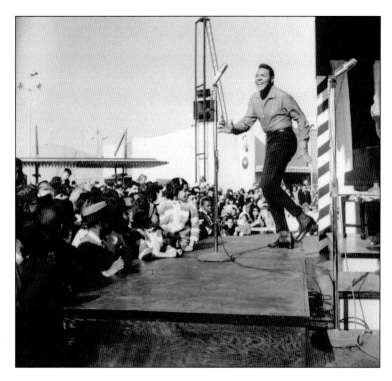

Trini Lopez (left) and Freedomland's Art Moss (center) are presenting Bronx borough president Joseph F. Periconi with an award. Lopez performed at the Moon Bowl Saturday and Sunday, May 16 and 17, 1964, along with Dionne Warwick, the Orlons, and others. Born in 1937, Lopez continues to perform today. (Courtesy of Frank R. Adamo collection; photograph by Bill Mitchell.)

For one week, August 29 to Labor Day, September 4, 1961, the Moon Bowl audiences got to witness three baby boomer icons: the Three Stooges. On stage are Moe Howard, Larry Fine, and Curly Joe De Rita. In the photograph below, backstage at Freedomland are, from left to right, a maintenance electrician, Joe Day, Moe Howard, Curly Joe De Rita, Frank R. Adamo, Larry Fine, and another maintenance electrician. There is actually a museum dedicated to the Three Stooges in Amber, Pennsylvania, called the Stoogeum.

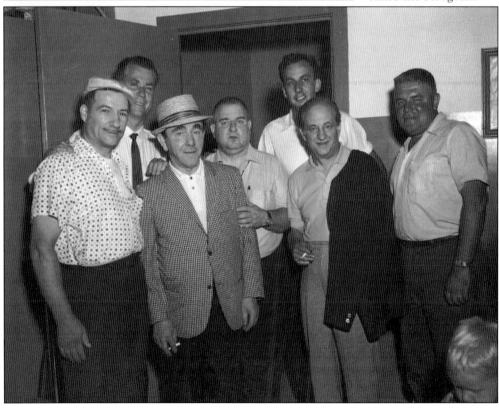

Walking down Fourteenth Street in Little Old New York during Freedomland's first season are four members from the original 1960 Broadway cast of *Bye Bye Birdie*. Pictured from left to right are Bob Spencer, 19; Mike Lamont, 14; Lada St. Edmund Jr., 15; and Gary Howe, 15. St. Edmund Jr. later gained fame on television's *Hullabaloo* as the lead dancer. She went on to become the highest paid stuntwoman in Hollywood's history.

On Sunday, August 5, 1962, the Lennon Sisters, Kathy, Peggy, and Janet, performed at the park. Rudy Vallee (right) and the cast of Broadway's *How to Succeed in Business Without Really Trying* were guests for the day, which included an appearance at the Moon Bowl. Also starring for one week starting August 5 were Xavier Cugat and Abbe Lane.

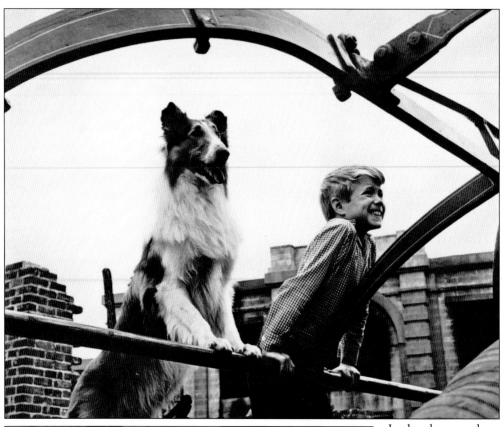

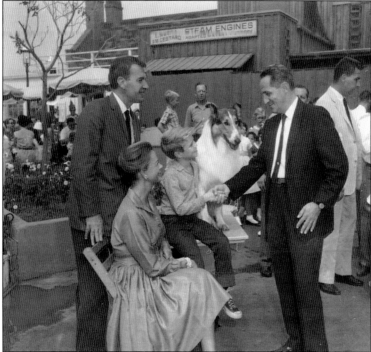

In the photograph above, Lassie and Jon "Timmy" Provost pose at the Chicago Fire Attraction. The photograph at left shows Freedomland's Art Moss shaking hands with Timmy, who is with his television parents, June Lockhart and Hugh Reilly.

In Little Old New York, a group of guests are in luck. They are enjoying a close up encounter with Hugh O'Brian, star of the popular television show *Wyatt Earp* from 1955 to 1961.

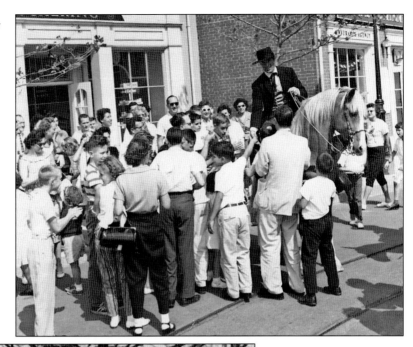

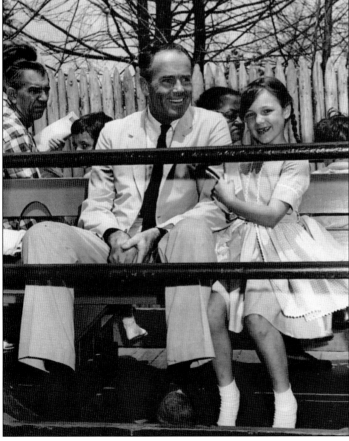

Taking a ride on Freedomland's Santa Fe Railroad is actor Henry Fonda and an unidentified girl—possibly Fonda's adopted daughter, Amy.

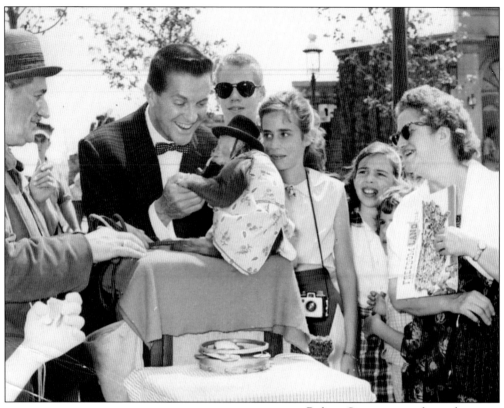

Robert Cummings is shown here shaking hands with Freedomland's in-house organ grinder monkey. This photograph is either from the 1960 or 1961 season.

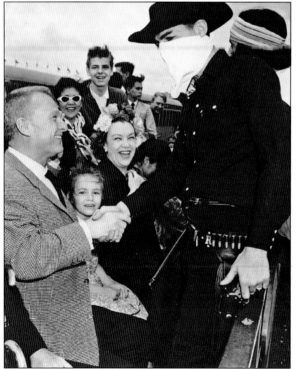

Film and television star Eddie Albert was on hand for the opening ceremony of Freedomland's second season on June 10, 1961. An accomplished actor in film, Albert is best remembered for playing the part of Oliver Wendell Douglas on the television show, *Green Acres*.

Former Brooklyn Dodger and 1962 Baseball Hall of Fame–inductee Jackie Robinson is seen here in a Freedomland appearance. Sitting left of him is Paul LaValle; standing from left to right are an unidentified man; Les Aries, producer for the Yankee games; Mrs. Art Moss; and Art Moss. Freedomland had its share of personalities in the five years that it was open.

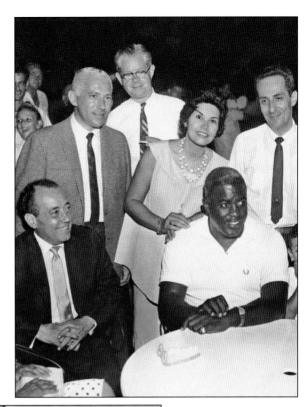

Johnny Roventini is seen here visiting Little Old New York. Roventini had a long relationship with the Philip Morris Company starting in 1933, and despite other roles is best remembered as the Philip Morris bellboy, with his famous tagline "Call for Philip Morris."

Coauthor Frank R. Adamo is seen in the back seat here as singer Jackie Wilson (left) and his chauffeur promote Freedomland by driving around in New York City in this photograph, taken at 125th Street, Harlem. (Courtesy of Frank R. Adamo collection; photograph by Bill Mitchell.)

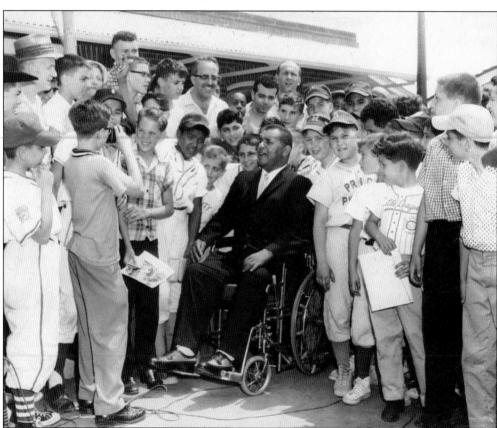

How excited are these kids? In this undated photograph, baseball legend and future Hall-of-Famer Roy Campanella of the Brooklyn and Los Angeles Dodgers makes an appearance at Freedomland.

Four

AFTER FREEDOMLAND

On September 15, 1964, Freedomland, Inc., filed a petition for bankruptcy in federal court. Competition from the New York World's Fair may have been a factor in the loss of attendance. Ultimately, Freedomland's land became more valuable than the business. Freedomland would not open for a sixth season. Coauthor Frank R. Adamo summed up Freedomland's demise by saying, simply, "The park failed to make a profit." Many other factors contributed to Freedomland's end, including huge cost overruns for construction, high maintenance and operating expenses, weather, and competition from established parks such as Playland in Rye, New York, and Palisades Park in Palisades, New Jersey. The attractions were auctioned off in 1965. Adamo was in charge of clearing off Freedomland's attractions and buildings for National Development Corporation, the last owners of Freedomland. Adamo ran the massive landfill operation for a number of years to raise the grade of the Freedomland site for redevelopment. Adamo recalls concrete and other clean debris from the 1973–1975 original Yankee Stadium renovation coming to this site. The Bay Plaza Shopping Center now sits on top of some of the old Yankee Stadium debris, which sits on top of the old Freedomland site.

The United Housing Foundation, headed by Abraham E. Kazan, announced plans in 1965 to construct Co-op City. Groundbreaking took place on May 14, 1966. Families started moving in to the first buildings in the fall of 1968.

Co-op City is managed by the Riverbay Corporation. Its corporate Web site describes it as "a New York City housing corporative located in the northeast Bronx with 15,372 residential units in 35 high-rise buildings and 7 townhouse clusters. Co-op City has approximately 50,000 residents."

Photographs in this chapter represent some of the components of Freedomland still in use or in storage, as of 2009. Adamo recalls that Cedar Point Amusement Park in Sandusky, Ohio, purchased the San Francisco Earthquake and Buccaneers dark rides, which are no longer in operation at Cedar Point. Also, Canada's Seagram Corporation purchased several of the attractions including Spin-A-Top for an amusement park they built for their Seagram Tower (now the Minolta Tower) at Niagara Falls. The Pirate Shooting Gallery ended up at Pirates World in Fort Lauderdale, Florida. What was not sold was torn down and removed, thus ending a very short life for the "Disneyland of the East."

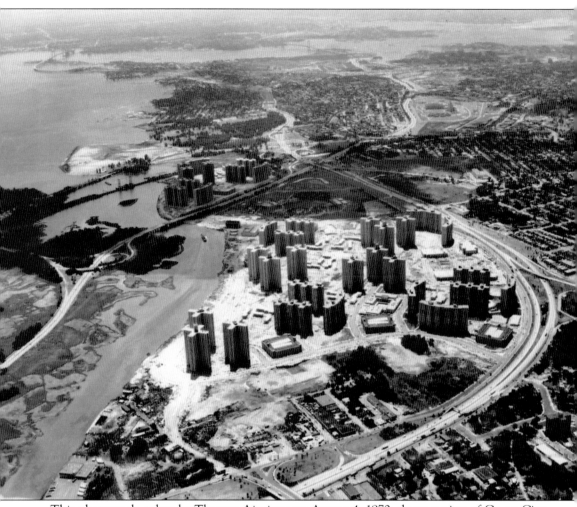

This photograph, taken by Thomas Airviews on August 4, 1970, shows a view of Co-op City and the vacant area that Freedomland once occupied. To the lower left is the Hutchinson River. At the top of the vacant site where the New England thruway I-95 (right) and the Hutchinson River Parkway (left) intersect is the U-shaped foundation for the Freedomland Inn, which was never constructed. According to Frank R. Adamo, the four buildings still standing on the park site were the operations and support facilities. They were rented out to the Riverbay Corporation, the sponsor building Co-op City. Bay Plaza currently occupies the former park site. Part of Co-op City sits on the park's parking lot. The area where the Freedomland Inn was going to be built is home to the first enclosed fashion mall in New York City in almost 40 years. "The Mall at Bay Plaza" is expected to open in August 2014 with 80 to 90 stores. (Courtesy of Frank R. Adamo collection; photograph by Thomas Airviews.)

In the shop at Boothbay Railway Village in Boothbay, Maine, is the Monson No. 3 locomotive, currently (fall 2009) being overhauled. No. 3 was at Boston's Pleasure Island for their first season, and then it went to Freedomland for five seasons. Also at Railway Village is a closed coach car that was reportedly from Freedomland's Santa Fe Railroad. (Courtesy of Robert McLaughlin.)

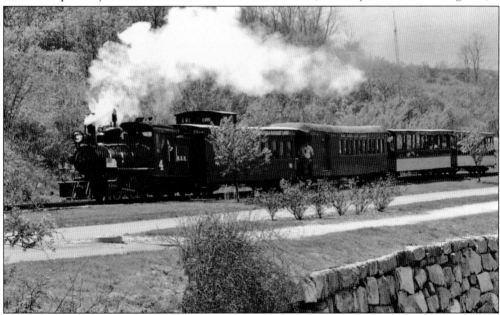

The No. 4 Monson locomotive currently resides at Maine's Narrow Gauge Railroad and Museum in Portland. For former Freedomland guests wanting to relive a part of the Santa Fe Railroad attraction, the Boothbay and Portland museums are the places to go. (Courtesy of Maine Narrow Gauge Railroad and Museum; photograph by Arthur M. Hussey II.)

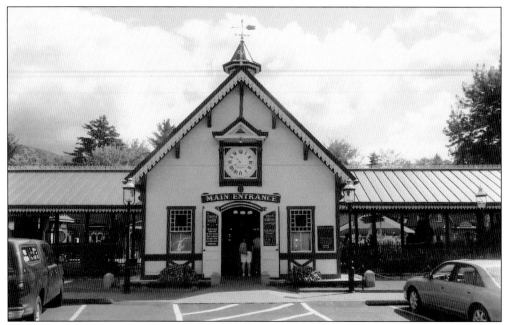

Clark's Trading Post, located in Lincoln, New Hampshire, was one of a number of new homes for historic relics of Freedomland that were removed after closing down. Edward Clark purchased both the Chicago Station (above) and the trackside Santa Fe Station (below) for the ongoing expansion at Clark's. David and Eddie, just out of high school, were dropped off by their dad, Edward, in the fall of 1965. They both spent a bone-chilling winter dismantling the stations, which their dad hauled back to New Hampshire for reassembly. The Chicago Station is now the main entrance and station for Clark's White Mountain Central Railroad. The Santa Fe Station is now Segway Station for Wolfman's Segway Safari Park at Clark's. (Courtesy of Robert McLaughlin.)

The Casa Loca was a popular attraction in the Old Southwest. Boston's Pleasure Island had a similar walk-through attraction named the Slanty Shanty. Both attractions shared a common theme that has been duplicated throughout the country for decades. They are designed to disorientate the guests, and they work great! Clark's attraction is called "Tuttle's Rustic House" (above-below). According to David A. Clark, it was constructed using a set of Casa Loca blueprints from Freedomland. The wrought-iron fencing (above) is from the New Orleans section. The electrified antique gas post lights throughout Clark's also came from Freedomland. Even the seats from the Space Ship were used for several years at Clark's premier attraction, the Live Bear Show. (Courtesy of Robert McLaughlin.)

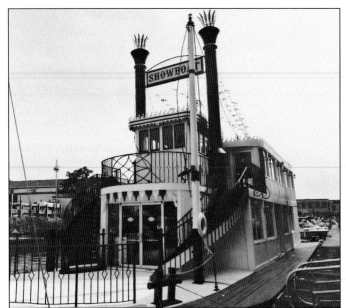

The stern-wheeler *Canadian* is on its third life after traveling around Freedomland's Great Lakes for five seasons. The vessel was sold after Freedomland closed and reopened as a floating restaurant. The new owners moored the showboat next to the Showboat Inn in Greenwich, Connecticut. Its present location is on the Byram River at the Highland Marina, Port Chester, New York. Permanently moored, the Showboat is now a jazz club owned by Bill Frenz. (Courtesy of Robert McLaughlin.)

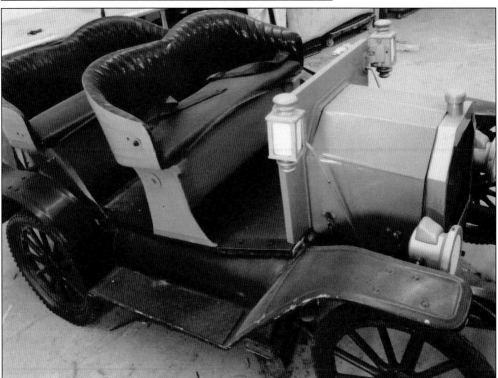

In 1954, the late Charles R. Wood opened a Mother Goose–themed amusement park in Lake George, New York, called Storytown USA. This park eventually evolved into Six Flags Great Escape and Splash Water Kingdom. He also opened Gaslight Village in Lake George as well. Wood purchased the King Rex Carousel, the Crystal Maze, both Danny the Dragons, two dark rides, the Mine Caverns, and the Tornado Adventure from Freedomland. This photograph is one of the cars from the Tornado Adventure currently in storage at Six Flags Great Escape. (Courtesy of Robert McLaughlin.)

Seen in storage here at Six Flags Great Escape and Splash Water Kingdom is one of two 74-foot Danny the Dragons. Wood sold the other years ago. He also sold the carousel and is rumored to have received $1 million for the carousel horses alone. Both of the dark rides have since been removed. The Crystal Maze was converted into a concession stand and no longer exists. (Courtesy of Robert McLaughlin.)

Also in storage at Six Flags Great Escape and Splash Water Kingdom are some of the "ore bucket" cars. The ride was sold to Seagram Tower in Ontario, Canada, but because of a steel embargo, it never made it across the border. It is pure speculation, but apparently Wood bought it at some point. Although the sky ride was never installed at his park, parts of the attraction may still be at other parks. (Courtesy of Robert McLaughlin.)

Built on the former Freedomland site is Bay Plaza. This complex has more than 50 stores, several national anchors, a multiplex cinema, a variety of dining opportunities, and many other services. Part of Co-op City, shown in this photograph, rises from where Freedomland's parking lot was located. (Courtesy of Robert McLaughlin.)

Straight ahead, beyond Bay Plaza's parking area, is the location of the Freedomland Inn site. Originally designed for 400 rooms (with room to expand), this motor inn was going to host an Olympic-size swimming pool, cocktail lounge, and restaurant. Scheduled to open for the summer of 1961, the project was halted after the footings and first floor concrete pad were installed. This inn was never completed because of ongoing financial pressures to make the park profitable. (Courtesy of Robert McLaughlin.)

The photograph above was taken opening day, August 19, 1960, looking towards Freedomland from Bartow Avenue. The photograph below was taken from the same location looking towards Co-op City and Bay Plaza in the summer of 2009. For a variety of reasons, Freedomland no longer physically exists. Nonetheless, the authors hope that within these pages, readers have enjoyed a visit back to Freedomland. Share your Freedomland stories and memories at FreedomlandUSA.org with links to several other Freedomland sites. (Below, courtesy of Robert McLaughlin.)

Discover Thousands of Local History Books
Featuring Millions of Vintage Images

Arcadia Publishing, the leading local history publisher in the United States, is committed to making history accessible and meaningful through publishing books that celebrate and preserve the heritage of America's people and places.

Find more books like this at
www.arcadiapublishing.com

Search for your hometown history, your old stomping grounds, and even your favorite sports team.

Consistent with our mission to preserve history on a local level, this book was printed in South Carolina on American-made paper and manufactured entirely in the United States. Products carrying the accredited Forest Stewardship Council (FSC) label are printed on 100 percent FSC-certified paper.